FLOWERS

A GARDEN OF
ORDINARY MIRACLES

AN ALPHABET BOOK

HIBISCUS

I'd like to give special thanks to Jane Lahr for her endless support and seemingly tireless ability of always doing exactly what has to be done (and then some—wow!), to Robb Pearlman, my eagle-eyed editor extraordinaire, for his many probing comments, and my wonderful designer, Kim Gatto, for putting up with all the many changes.

RRZ

A GARDEN OF ORDINARY MIRACLES

AN ALPHABET BOOK

ROBERT R. ZAKANITCH

UNIVERSE

This edition published in the United States of America in 2012
by Universe Publishing, A Division of Rizzoli International Publications, Inc.
300 Park Avenue South
New York, NY 10010
www.rizzoliusa.com

Art and text copyright © 2012 by Robert Zakanitch.

Designed by Kim Gatto

2012 2013 2014 2015 / 10 9 8 7 6 5 4 3 2 1

Printed in China

ISBN: 978-0-7893-2439-9

Library of Congress Control Number: 2012932507

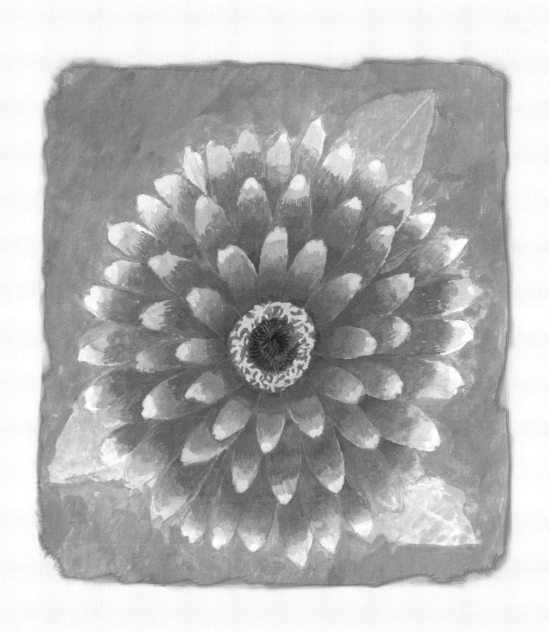

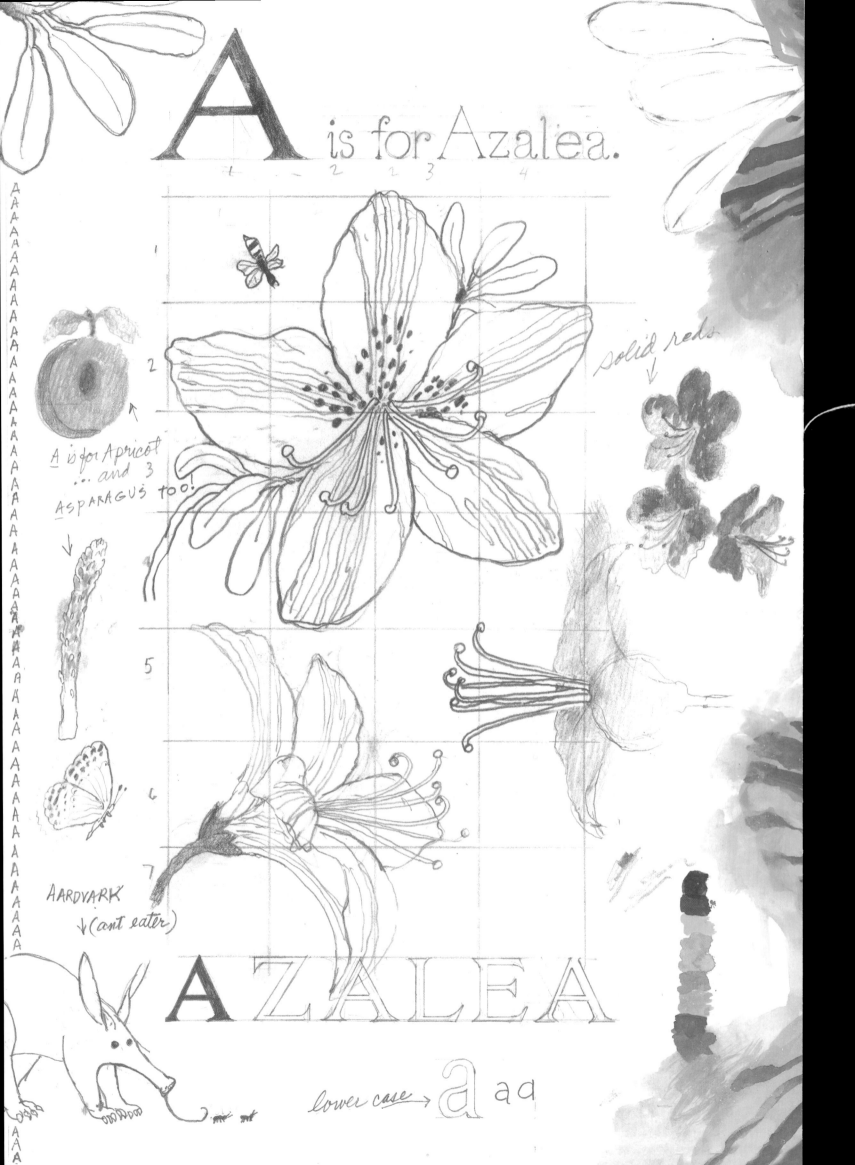

A

A is for Azalea.

1 — 2 2 3 4

solid reds
↓

A is for Apricot
... and 3
ASPARAGUS too!

↓

1

2

5

6

7

AARDVARK
↓ (ant eater)

AZALEA

lower case → a aa

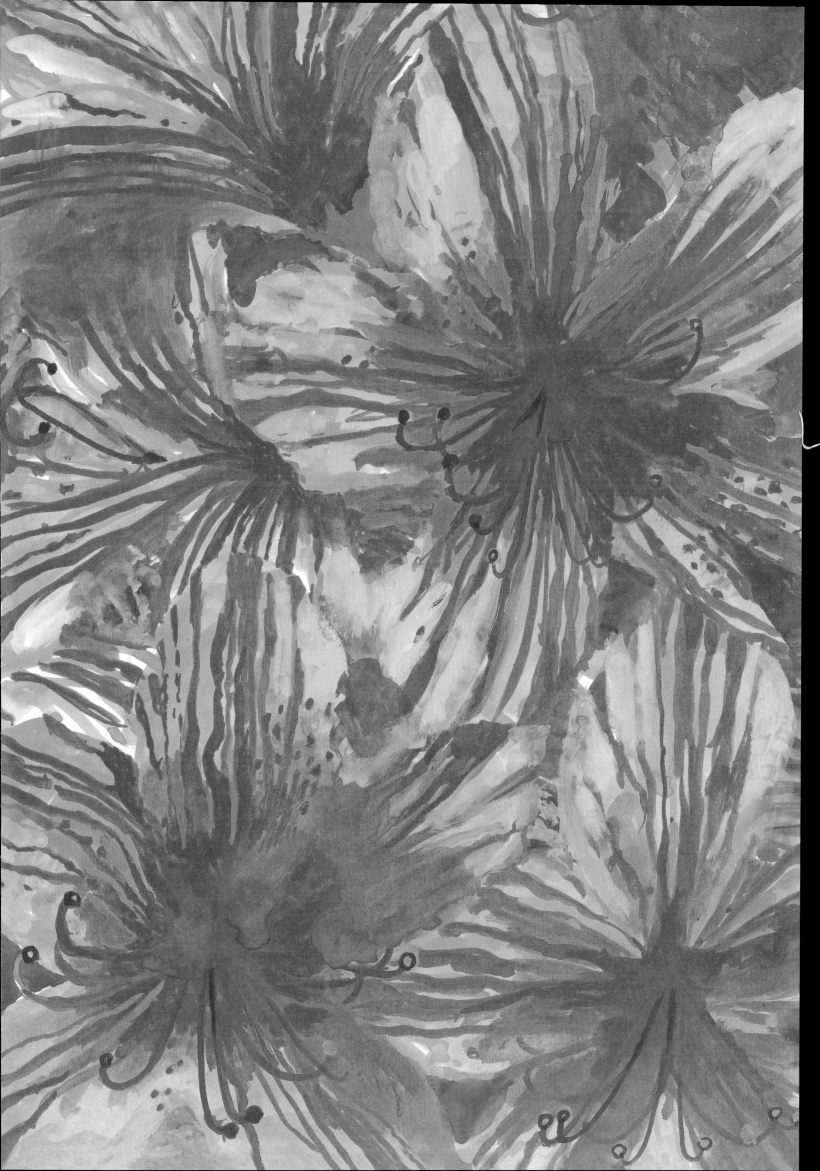

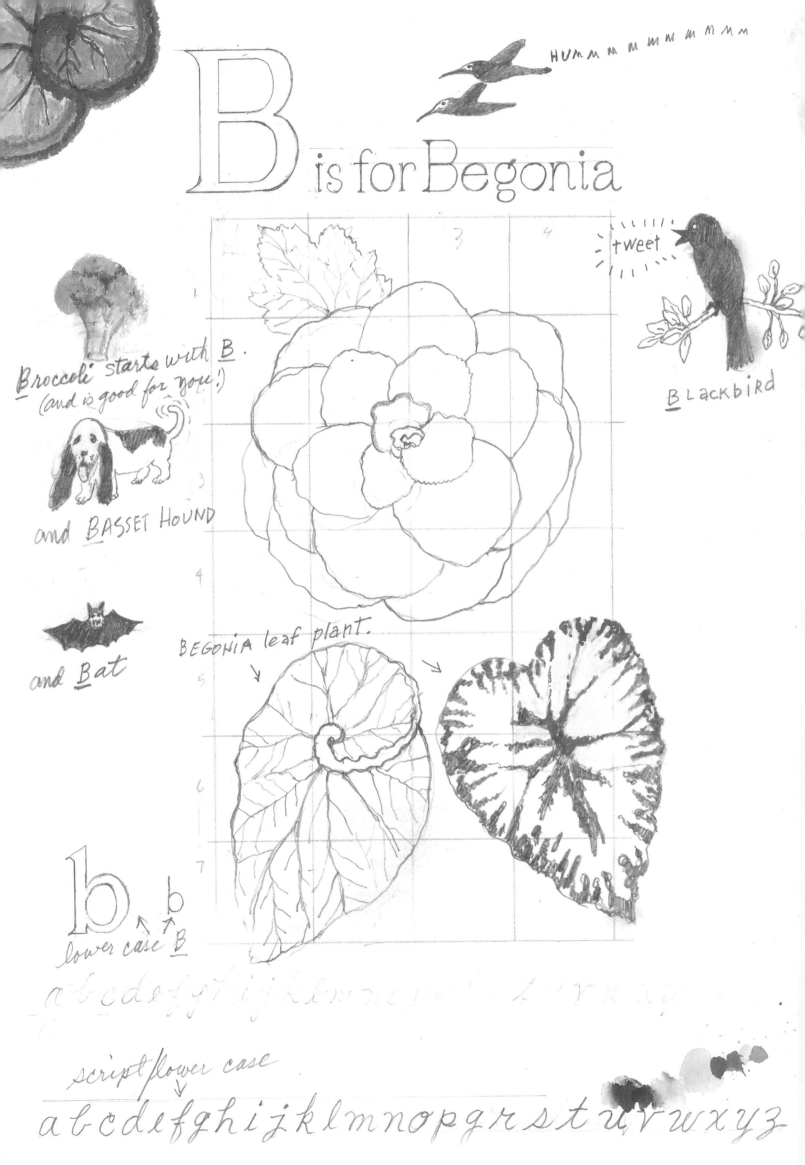

B is for Begonia

HUMMMMMMMMM

tweet

BLACKBIRD

Broccoli starts with B.
(and is good for you!)

and BASSET HOUND

and Bat

BEGONIA leaf plant.

b lower case B

abcdefghijklmnop qrstuvwxyz

script flower case

abcdefghijklmnopqrstuvwxyz

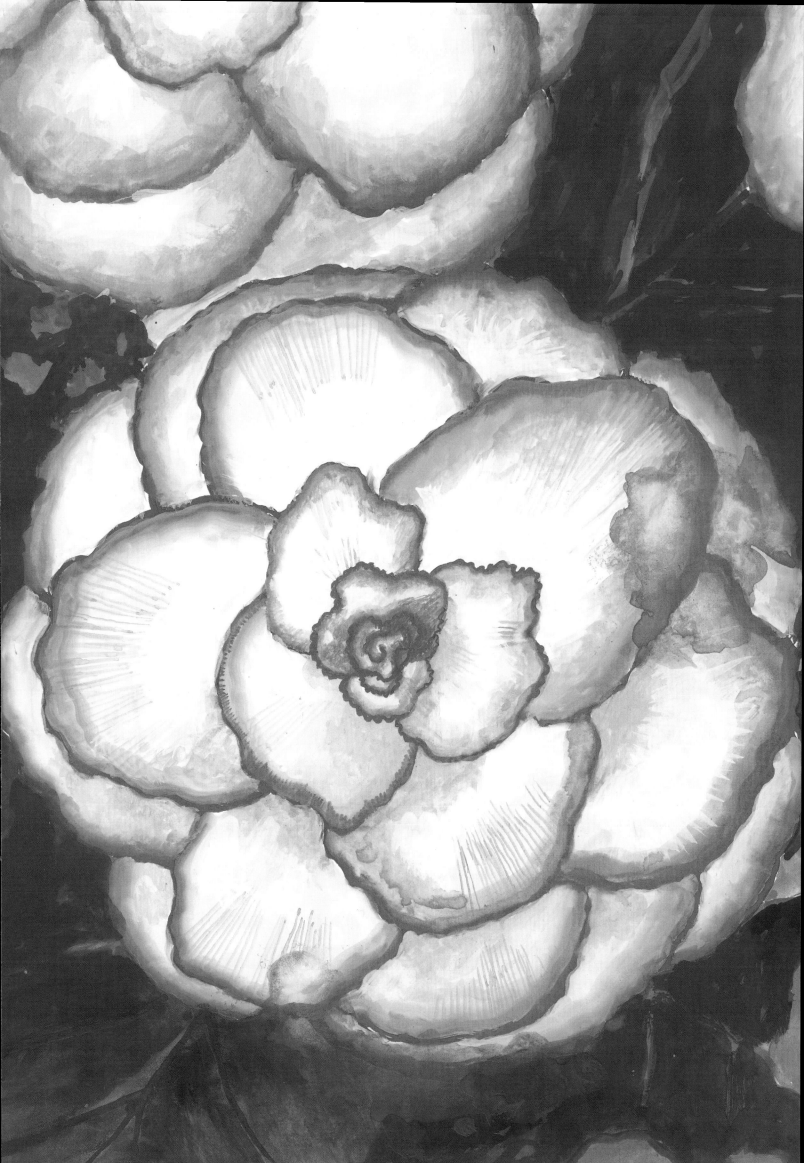

C is for Coleus

(KO-LEE-US)

AND FOR
CALADIUM

AND for
clematis

COLEUS

PEEP-PEEP

CALADIUM

CROWS

AND for
CARROT

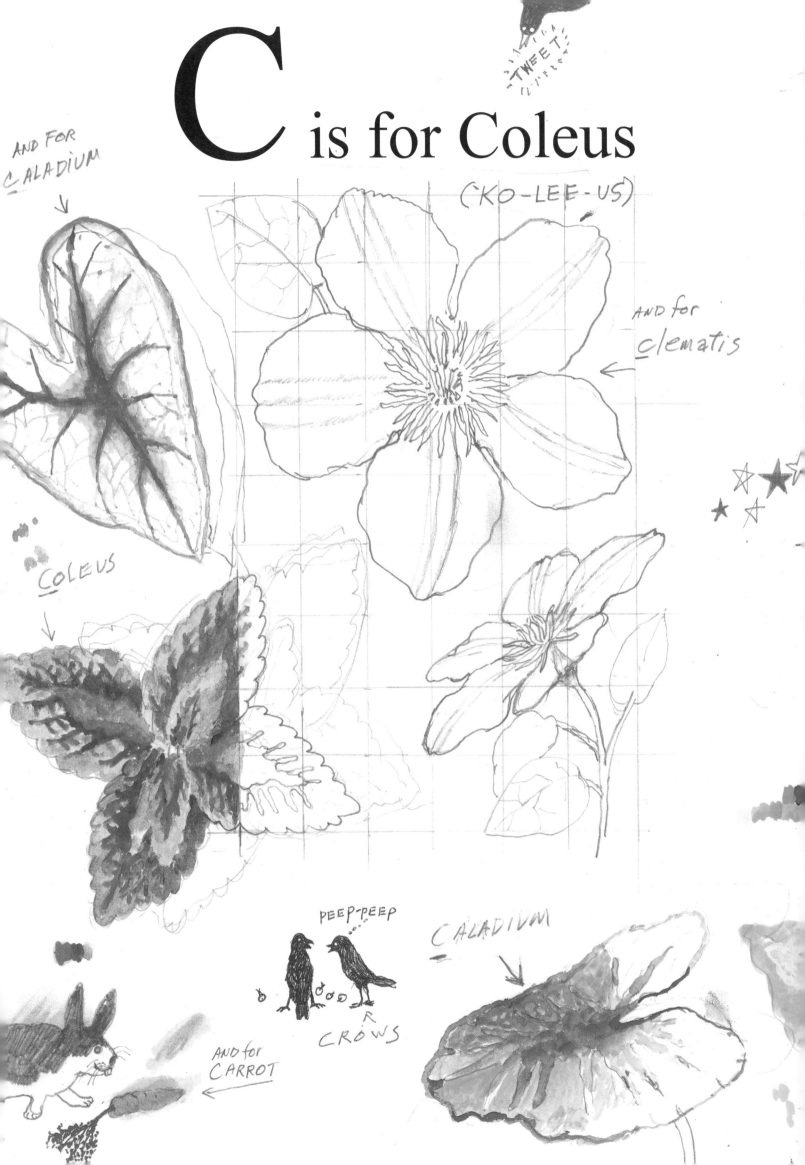

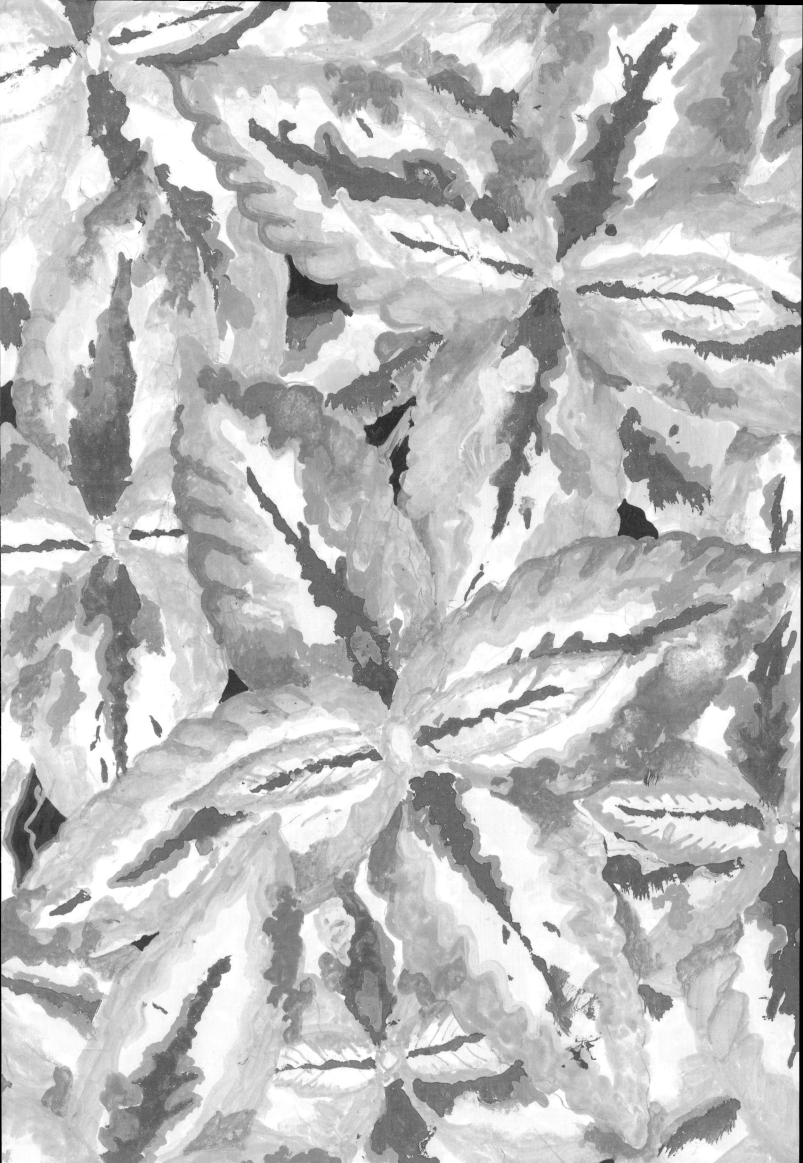

D is for Delphinium

(DELL -`FIN - E - UM)

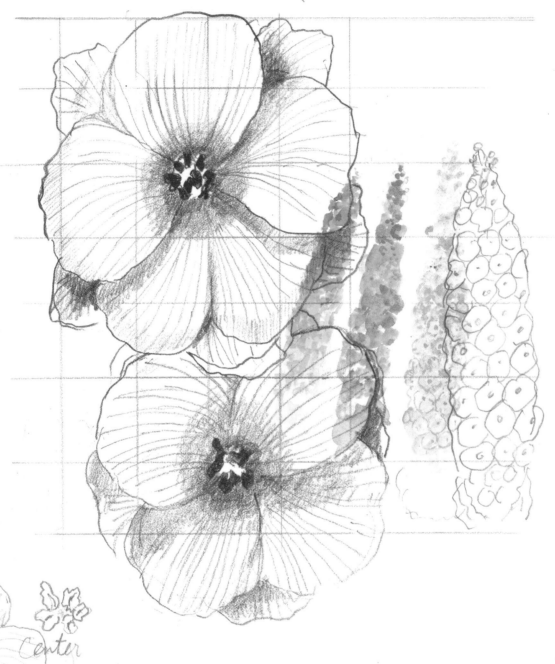

Center

CAPITALS → DELPHINIUM

lower case → delphinium

pronounced (del-`fin - e - um)

d d

upper + lower } case printed alphabet

ABCDEFGHIJKLMNOPQRSTUVWXYZ
abcdefghijklmnopqrstuvwxyz

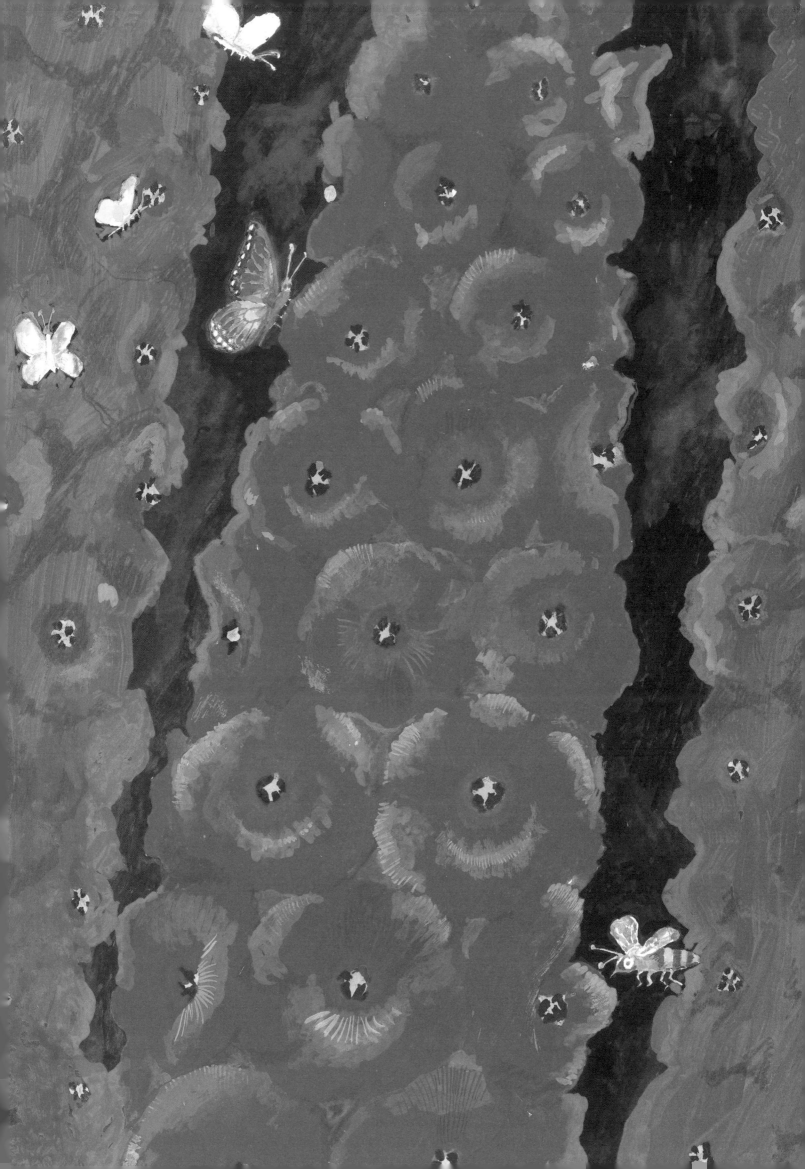

E is for Echeveria

(EH-CHA-VEREE-A)

they come in
soft Blue

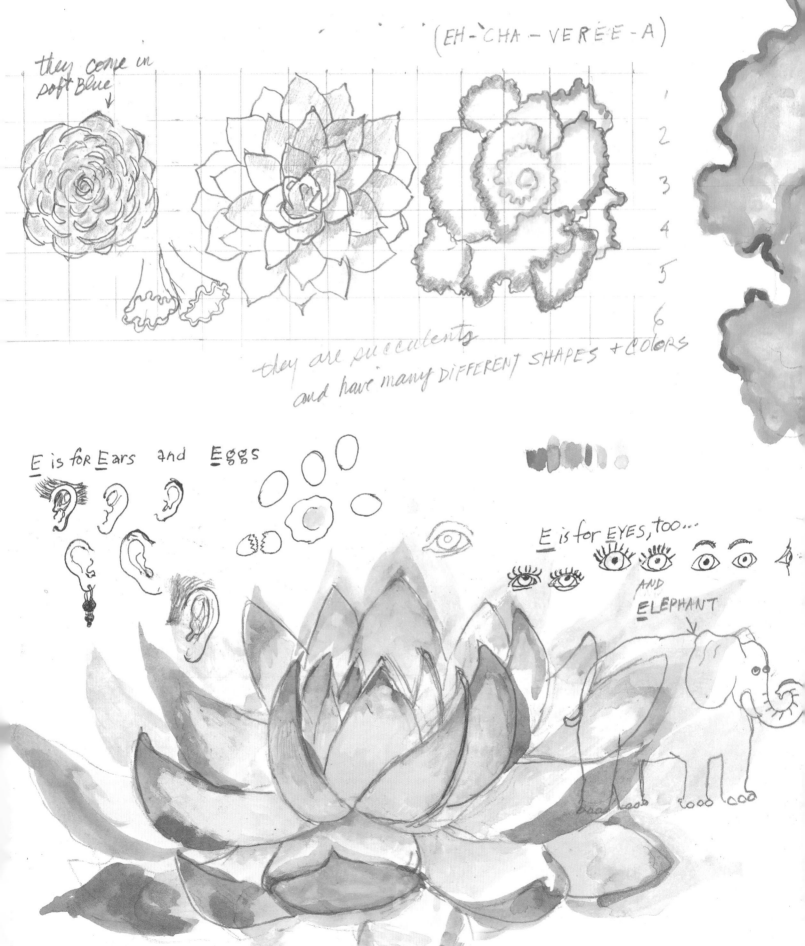

they are succulents
and have many DIFFERENT SHAPES + COLORS

1
2
3
4
5
6

E is for Ears and Eggs

E is for EYES, too...

AND
ELEPHANT

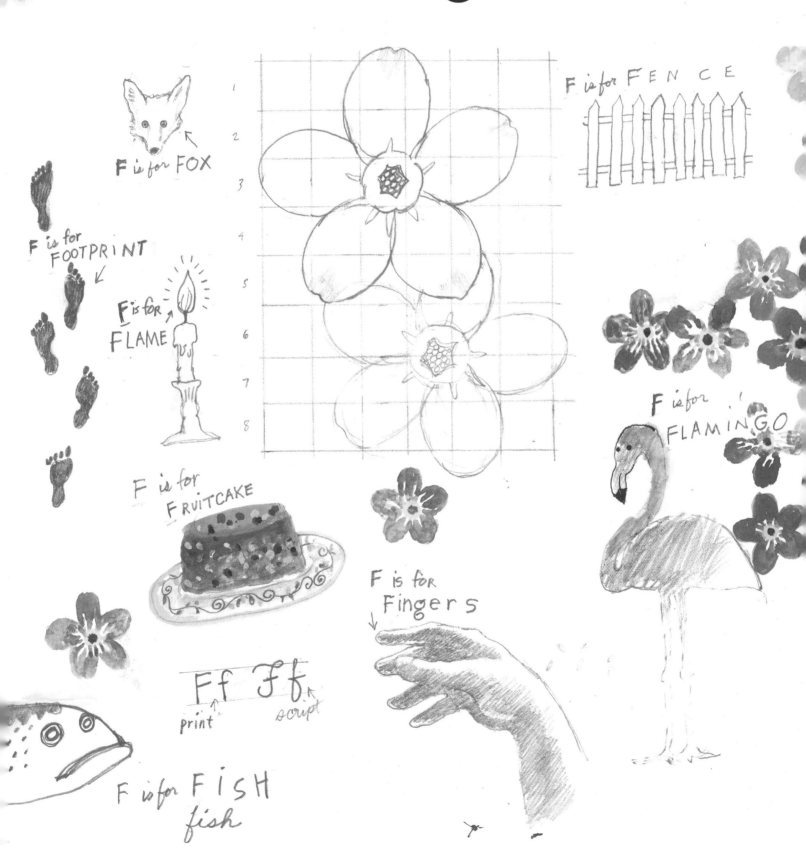

F is for Forget-Me-Nots

Frog →

F is for FOX

F is for FOOTPRINT

F is for FLAME

F is for FRUITCAKE

F is for FENCE

F is for FLAMINGO

F is for Fingers

Ff Ff
print script

F is for FISH
fish

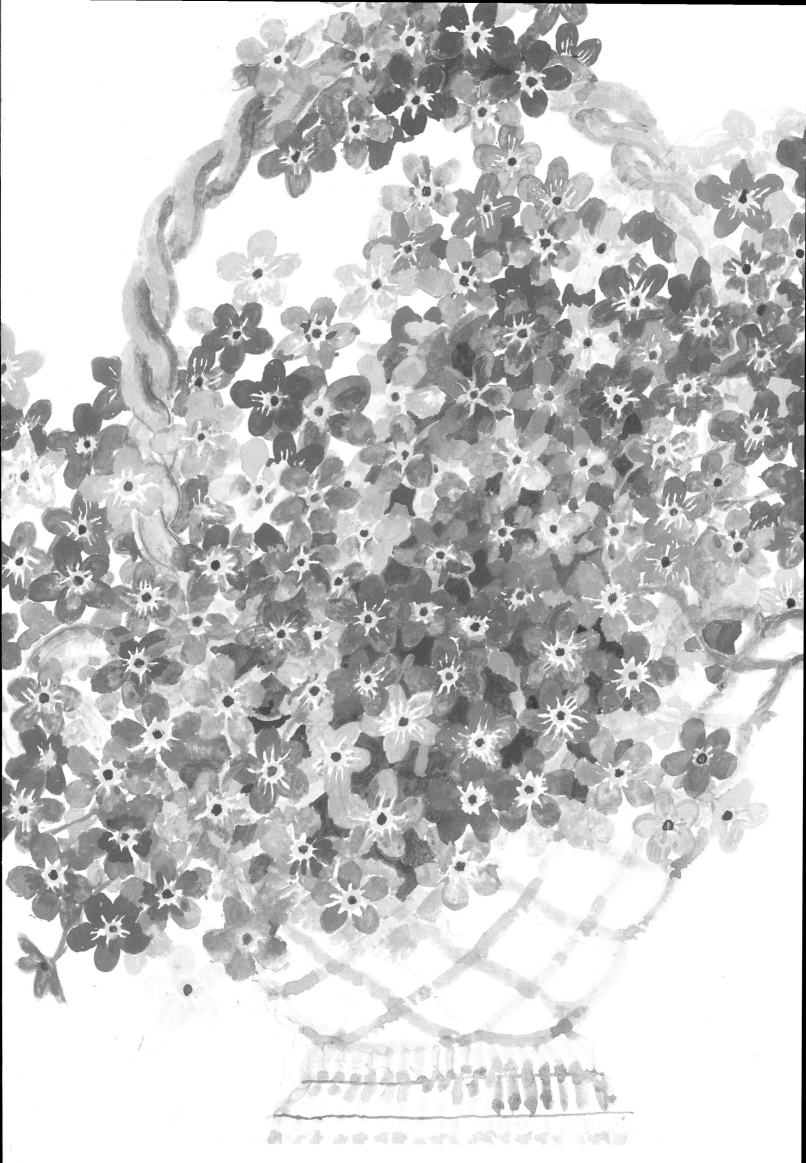

G is for Grass

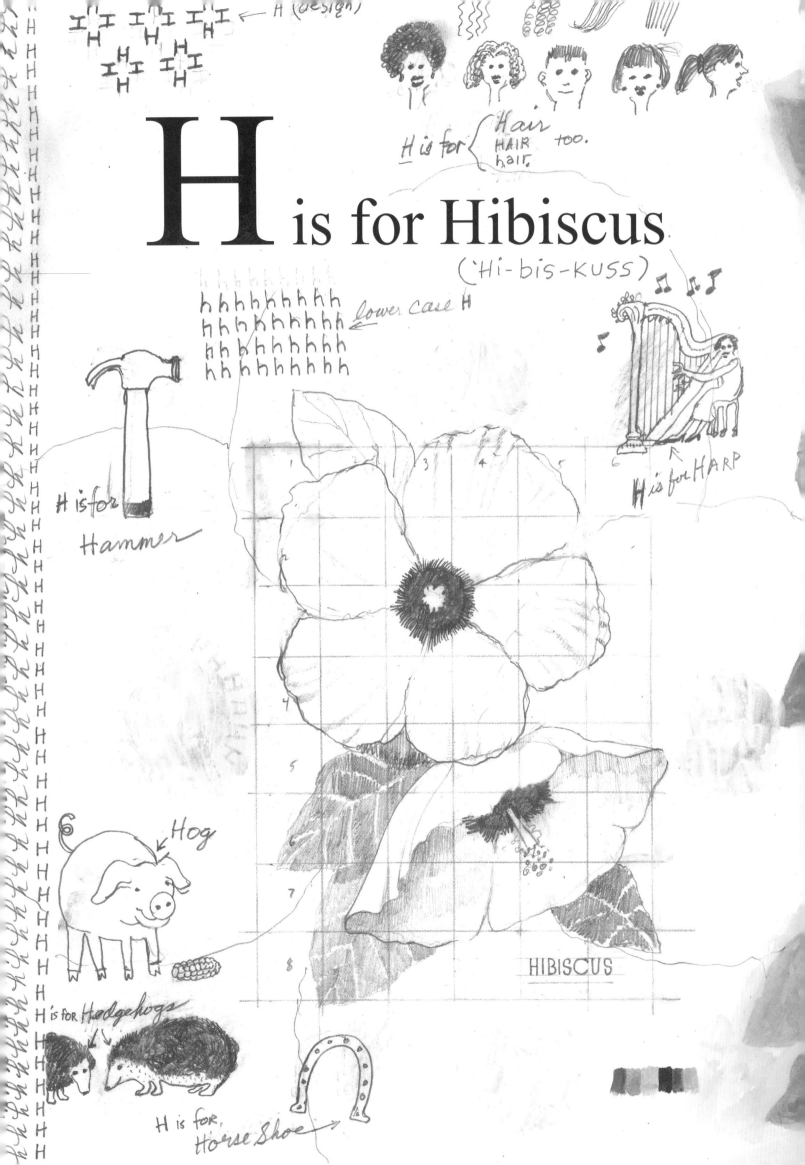

H (design)

H is for Hibiscus
('Hi-bis-kuss)

H is for { Hair, HAIR, too. hair. }

lower case H

H is for Hammer

H is for HARP

Hog

1 2 3 4 5 6
4
5
6
7
8

HIBISCUS

H is for Hedgehogs

H is for Horse Shoe

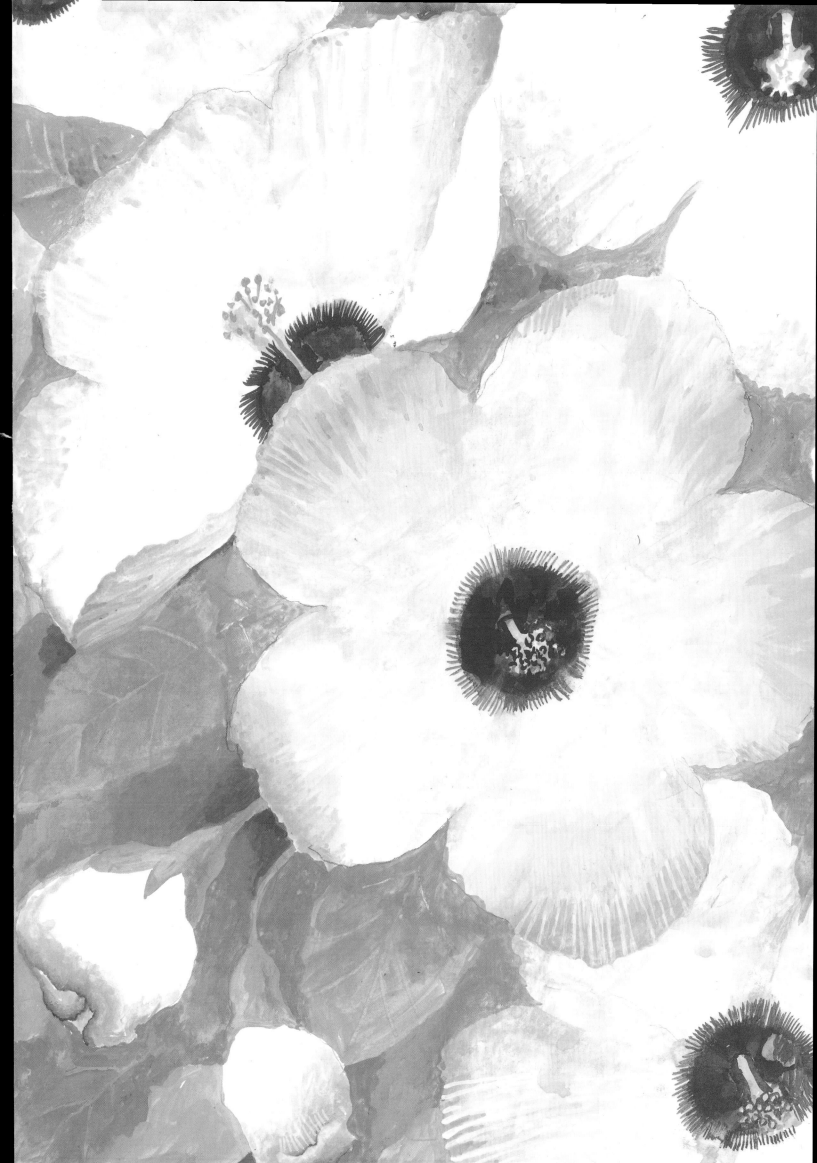

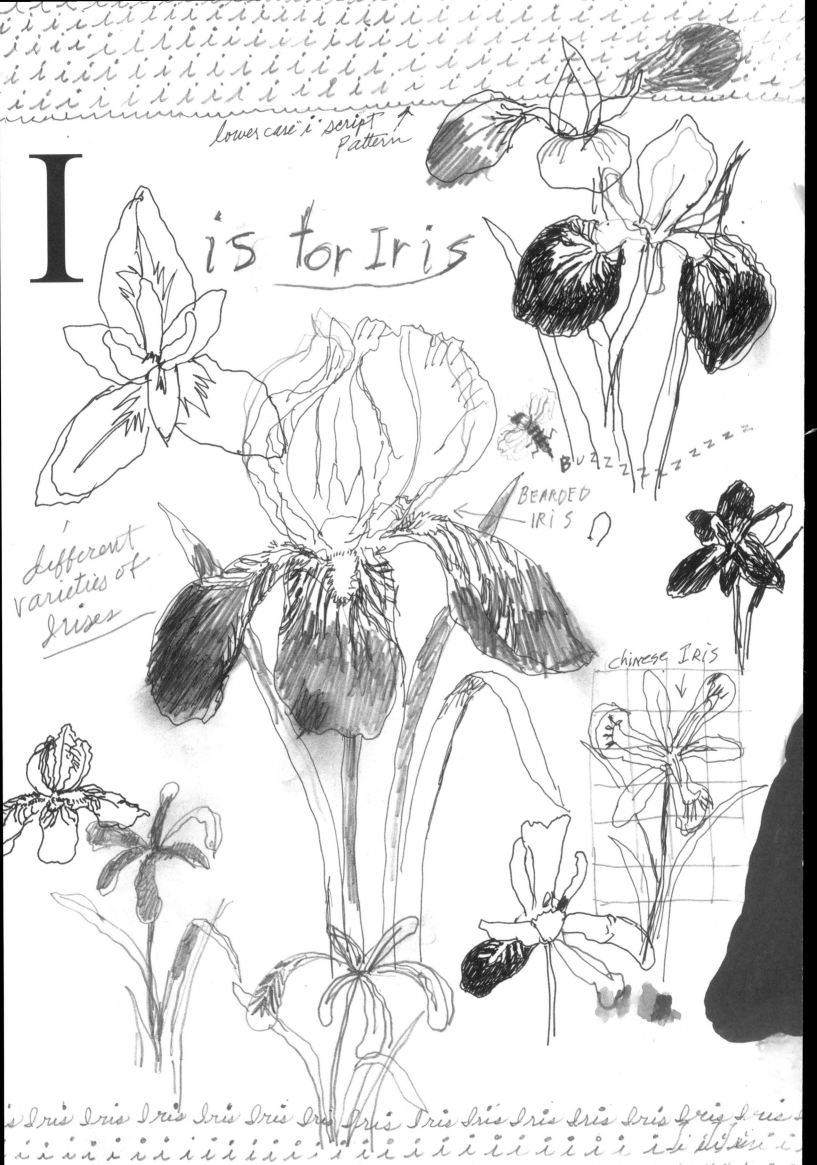

I

I is for Iris

lower case "i" script Pattern

different varieties of irises

BEARDED IRIS

BUZZZZZZZZ

chinese IRIS

Iris Iris Iris Iris Iris Iris Iris Iris Iris Iris Iris Iris Iris Iris

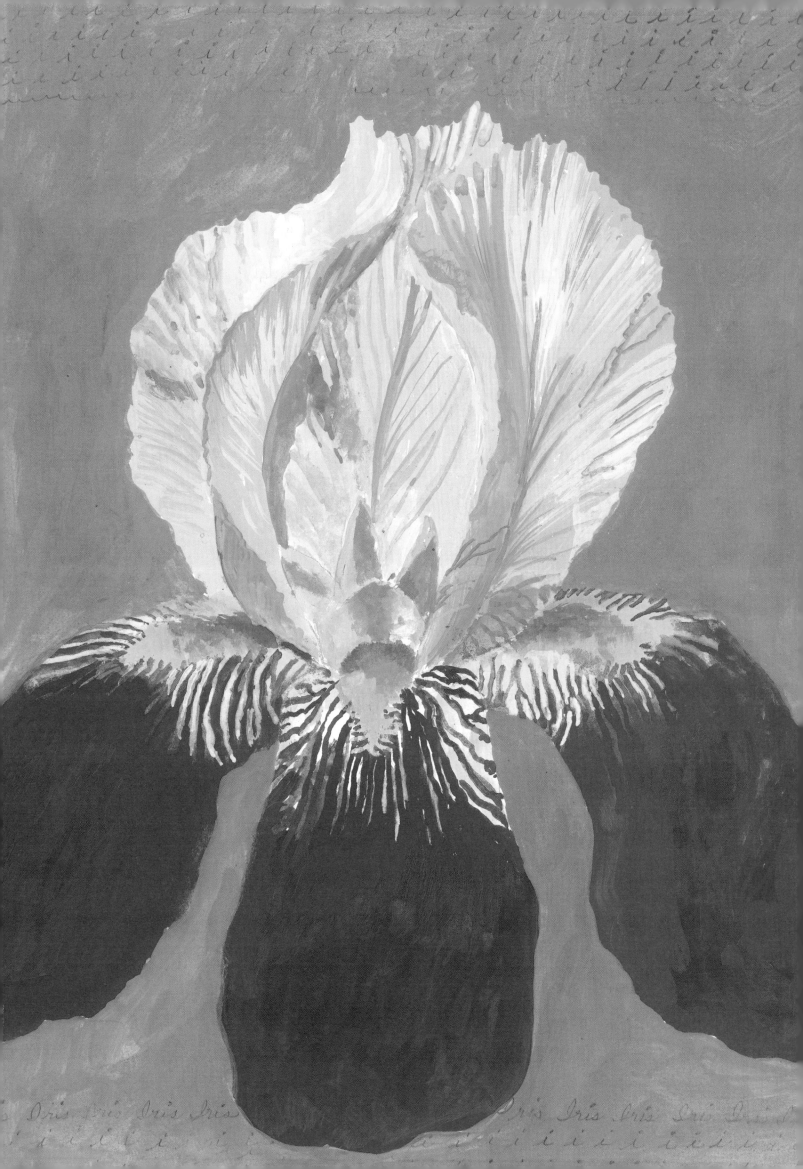

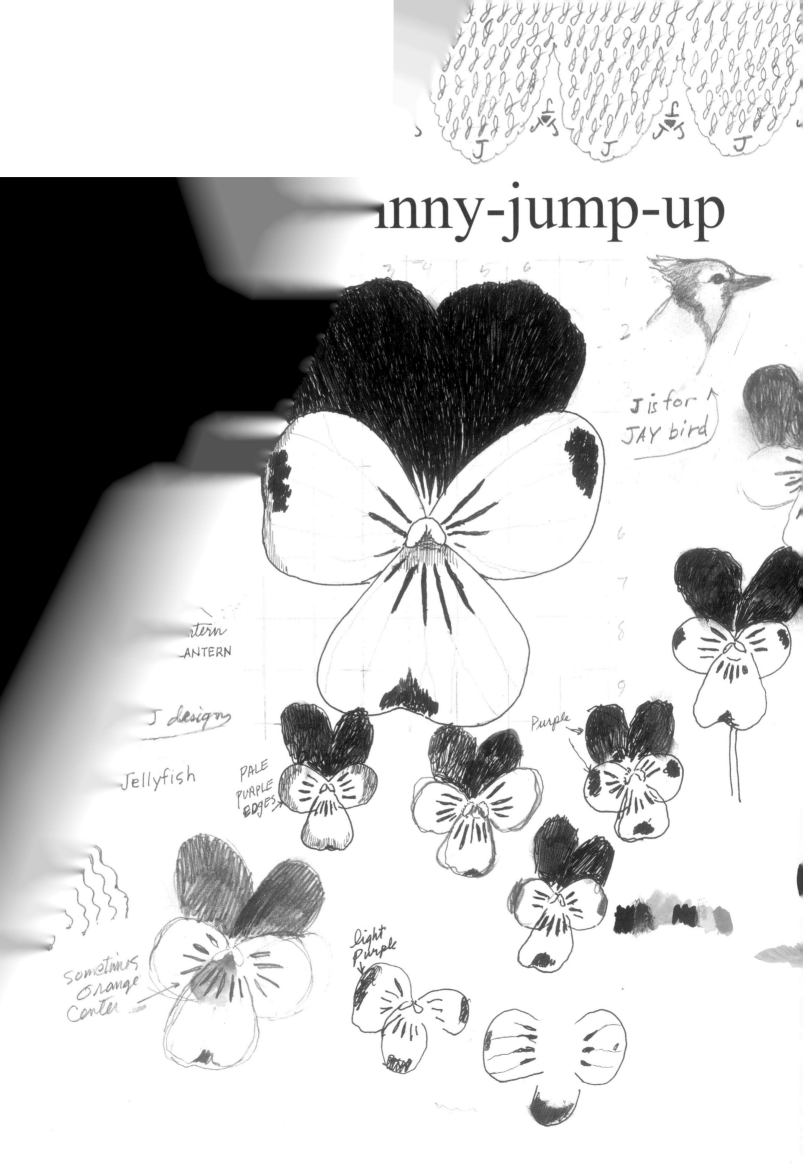

J is for
JAY bird

tern
ANTERN

J design

Jellyfish

PALE
PURPLE
EDGES

Purple

sometimes
orange
center

light
purple

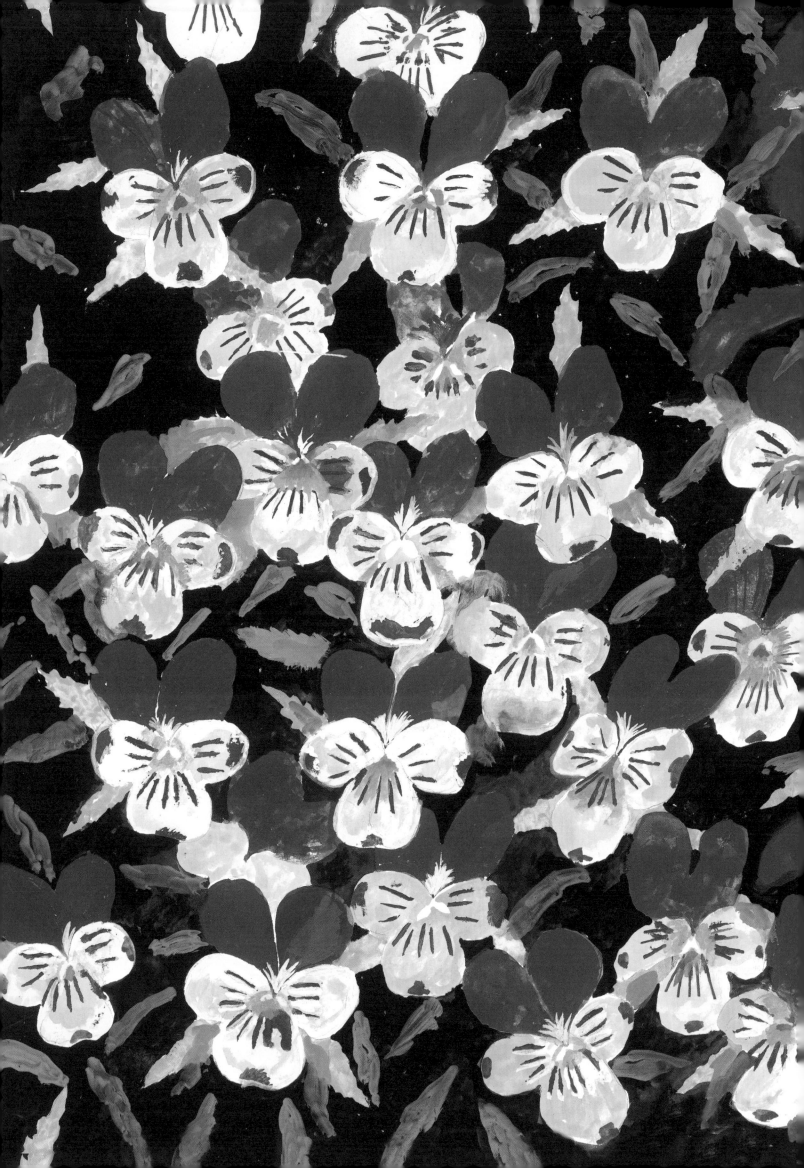

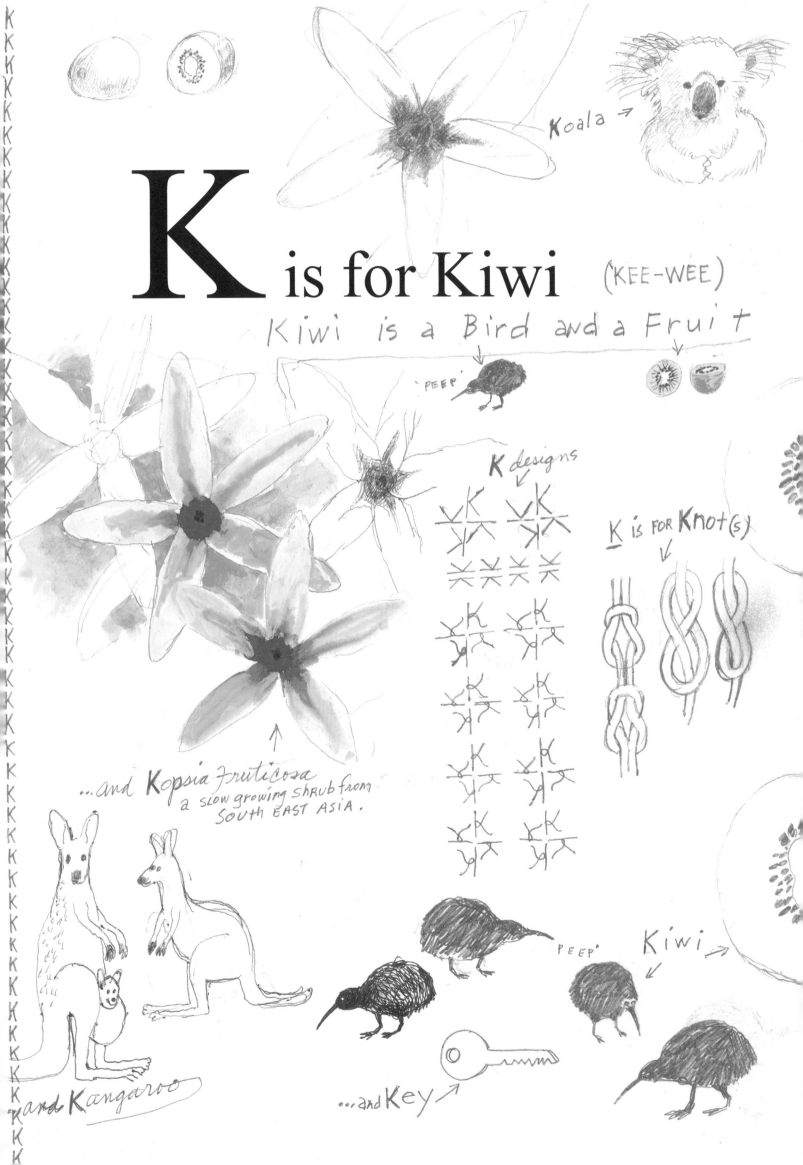

K is for Kiwi (ˈKEE-WEE)

Koala →

Kiwi is a Bird and a Fruit

'PEEP'

K designs

K is for **Knot**(s)

...and *Kopsia Fruticosa* a SLOW growing SHRUB from SOUTH EAST ASIA.

...and *Kangaroo*

'PEEP' Kiwi →

...and Key →

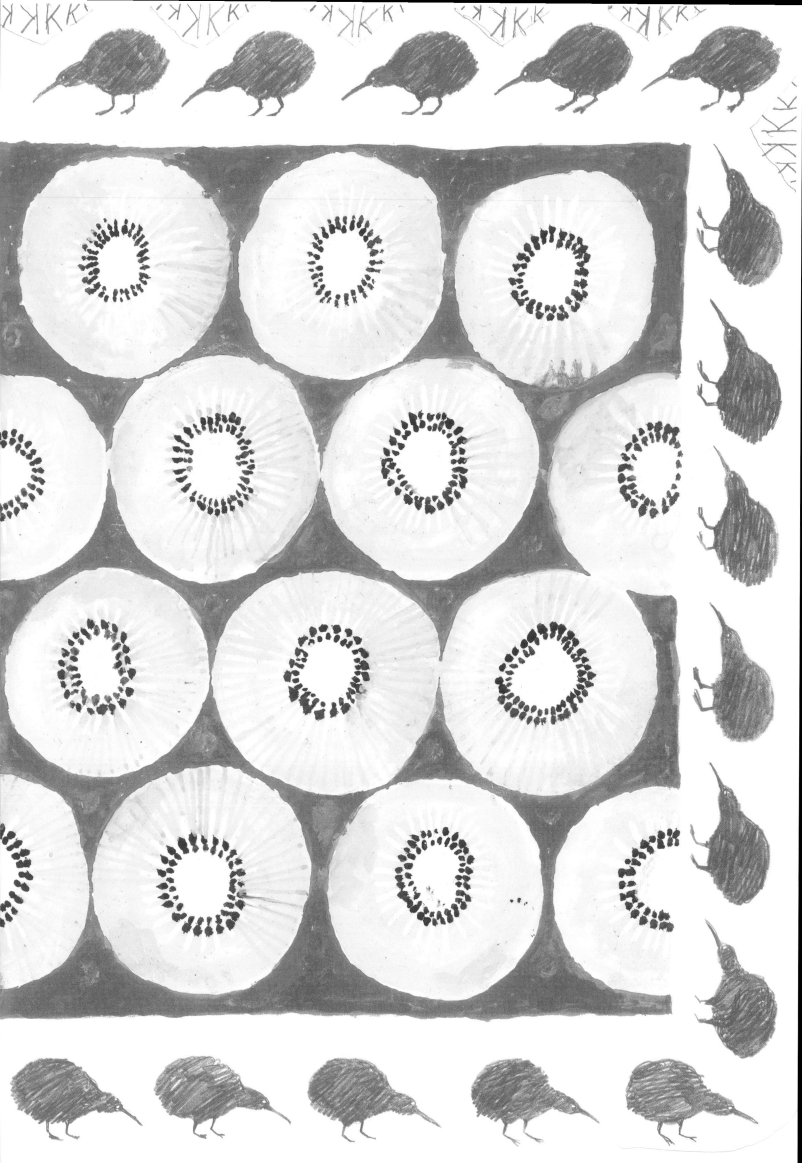

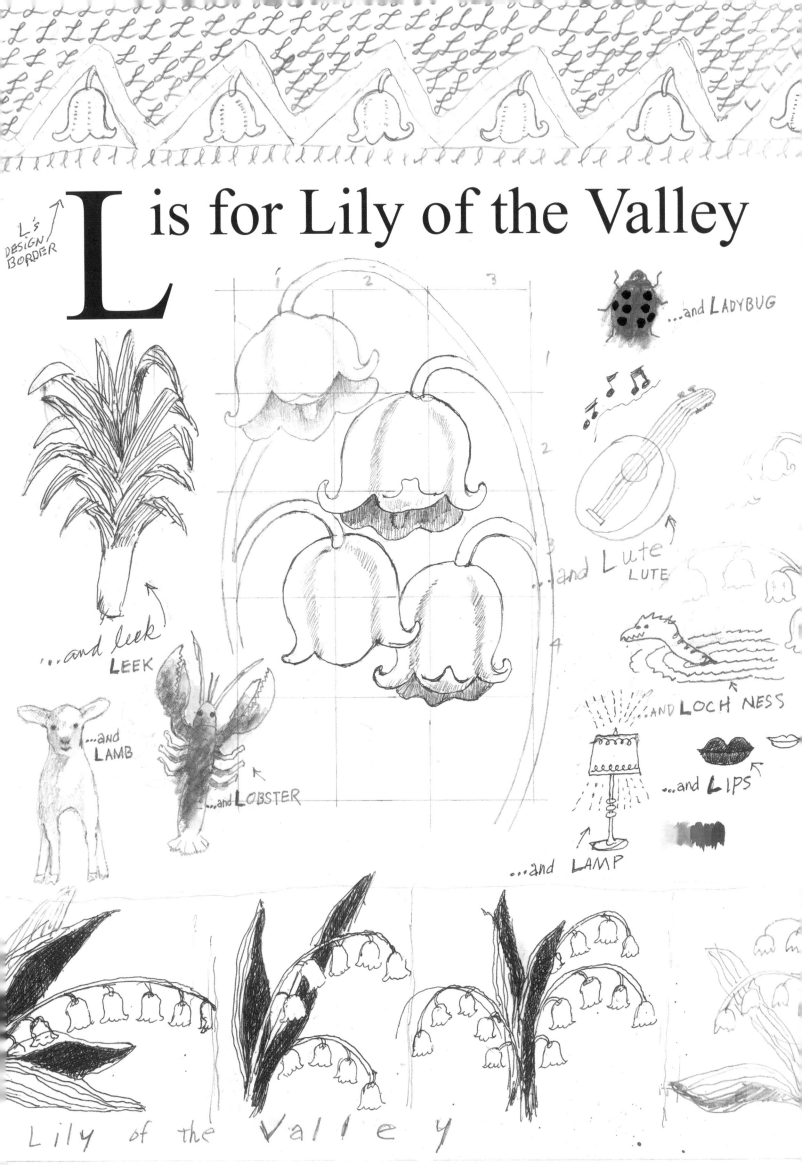

L is for Lily of the Valley

L's DESIGN BORDER

...and LADYBUG

...and LUTE LUTE

...and leek LEEK

...AND LOCH NESS

...and LAMB

...and LOBSTER

...and LIPS

...and LAMP

Lily of the Valley

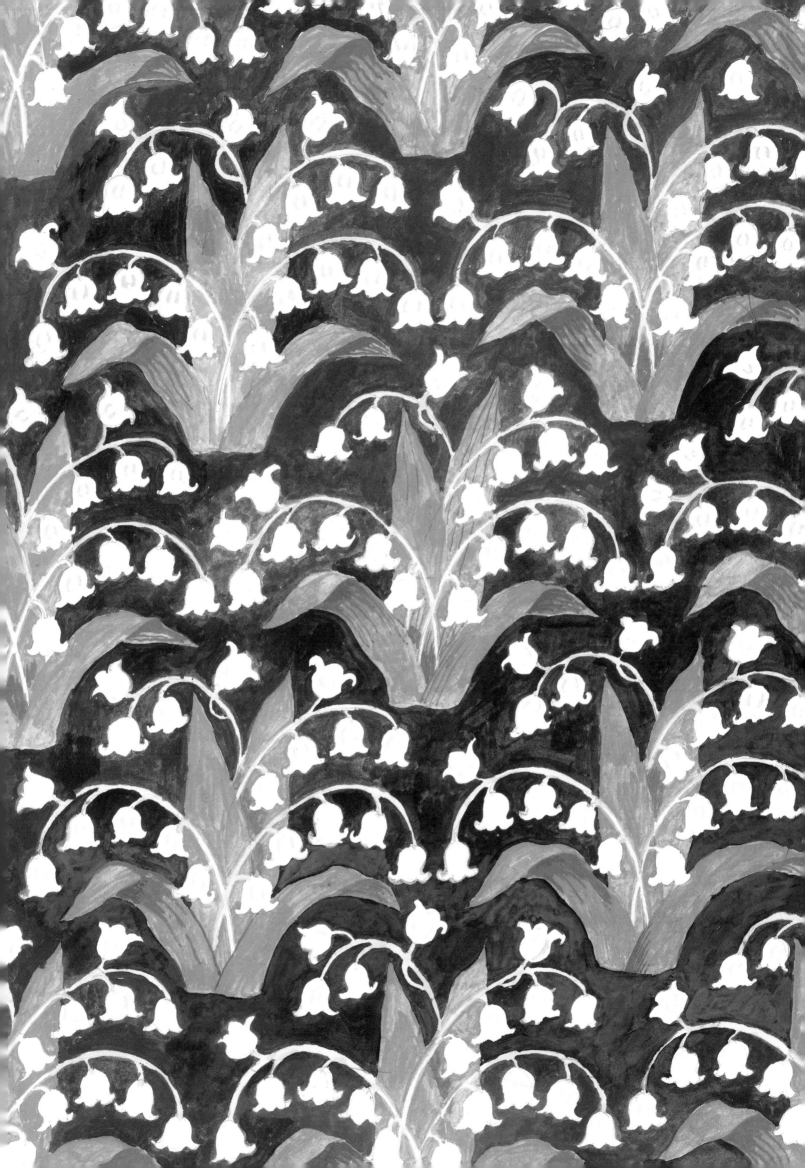

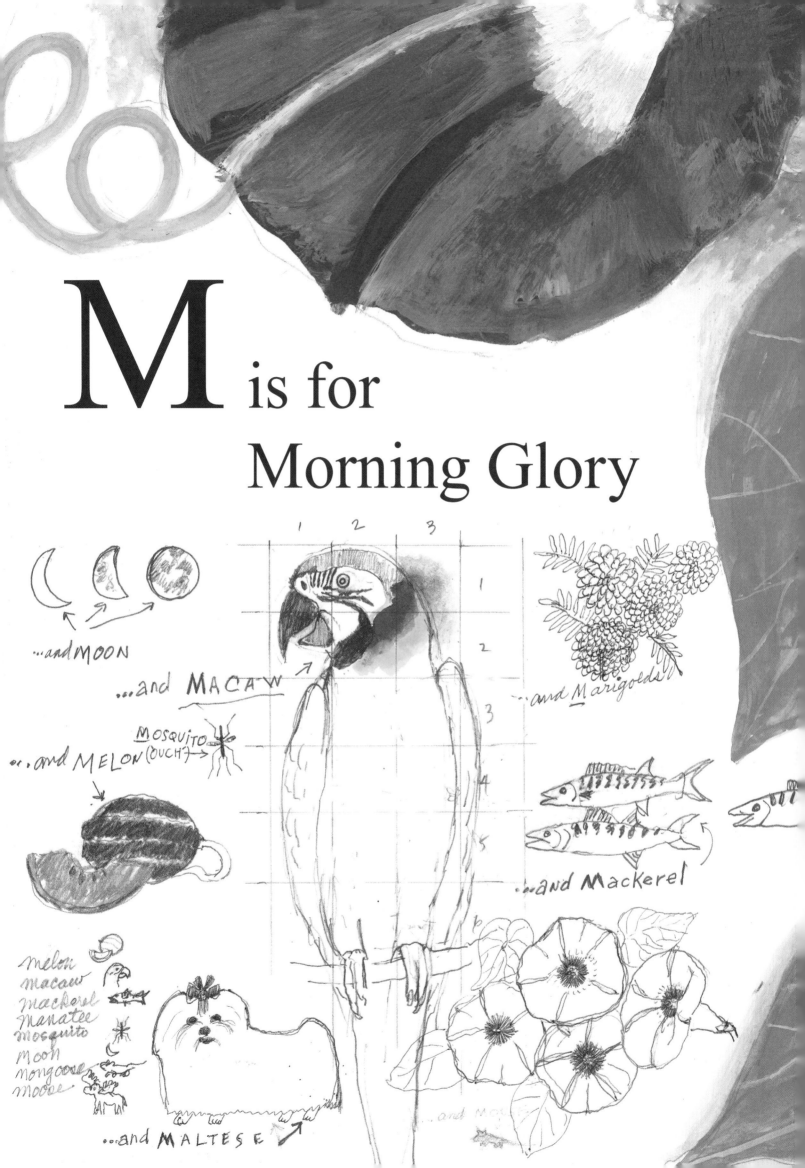

M is for Morning Glory

...and MOON

...and MACAW

MOSQUITO

...and MELON (OUCH?)

...and Marigolds

...and Mackerel

melon
macaw
mackerel
manatee
mosquito
moon
mongoose
moose

...and MALTESE

...and MO

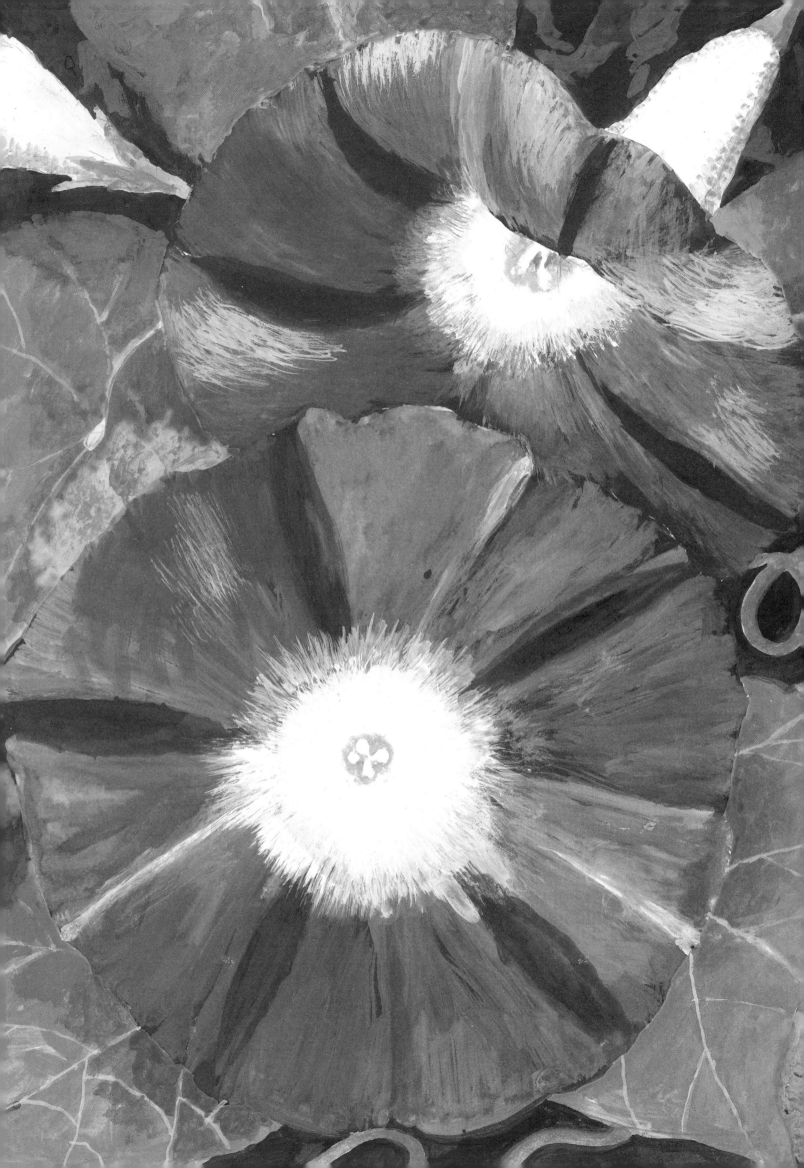

N

lower case n's

is for NASTURTIUM

(NA-'STIR-SHUM)

N N N n *n n*
↑ caps ↑

N N N
N N N N
N N N N N
N N N N
N N N

N N N N
N N N N N N
N N N N N N
N N N N N

N designs

"chirp"

...and Nuthatch

...and NARCISSUS

...and Nose ↑

Nightingale
Needlefish
Nuts

...and Nightingale

...and Needlefish

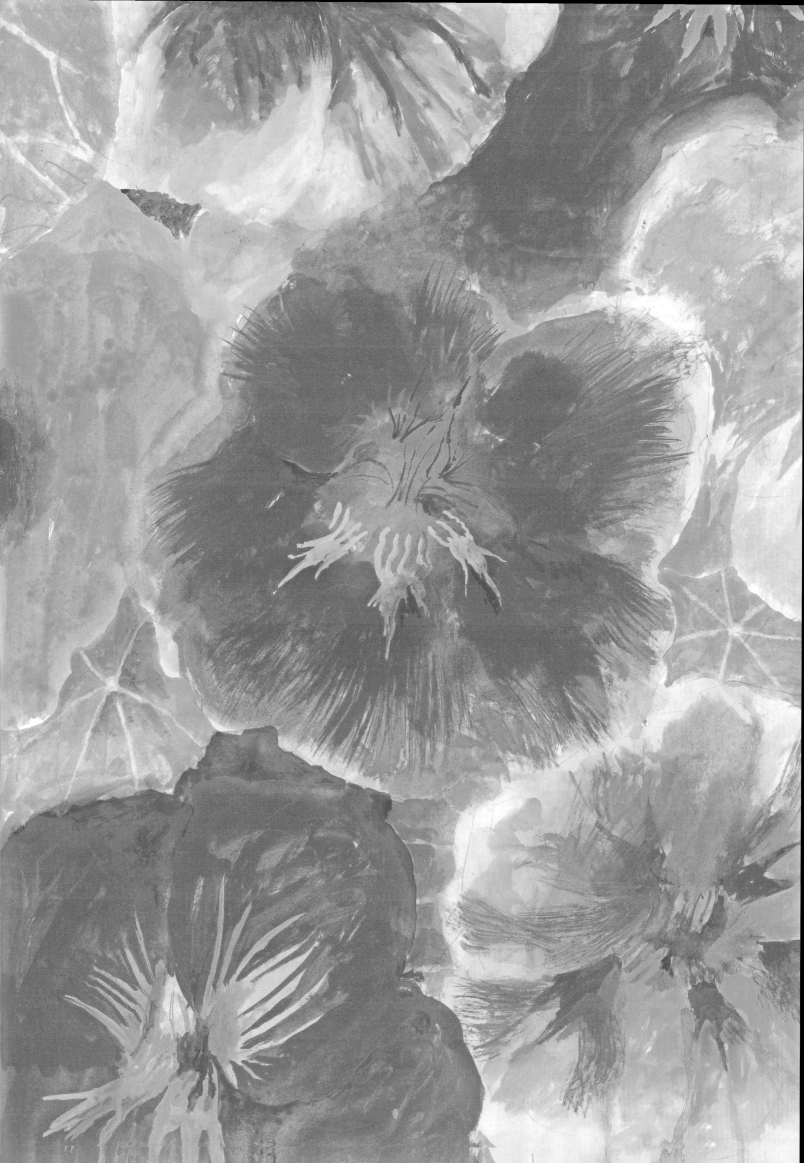

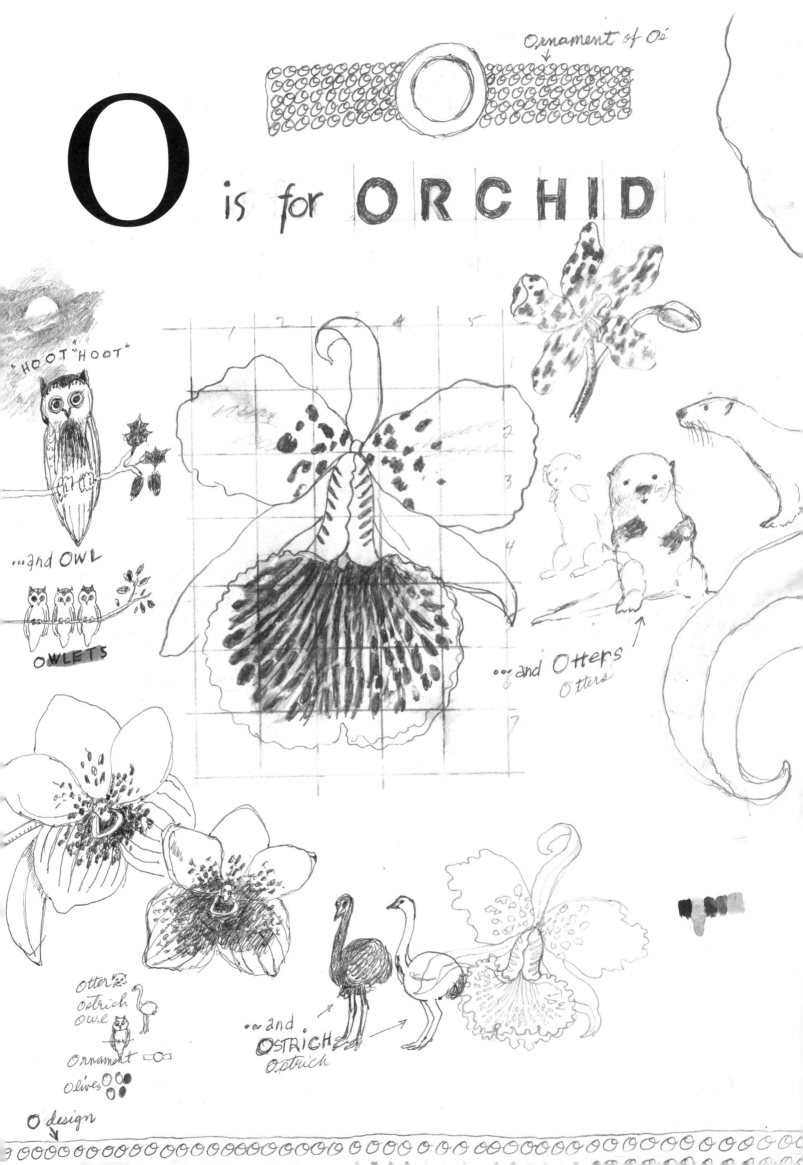

O

O is for ORCHID

"HOOT" "HOOT"

...and OWL

OWLETS

...and Otters
Otters

Otter's
Ostrich
Owl
Ornament
Olives

O design ↓

...and
OSTRICH
Ostrich

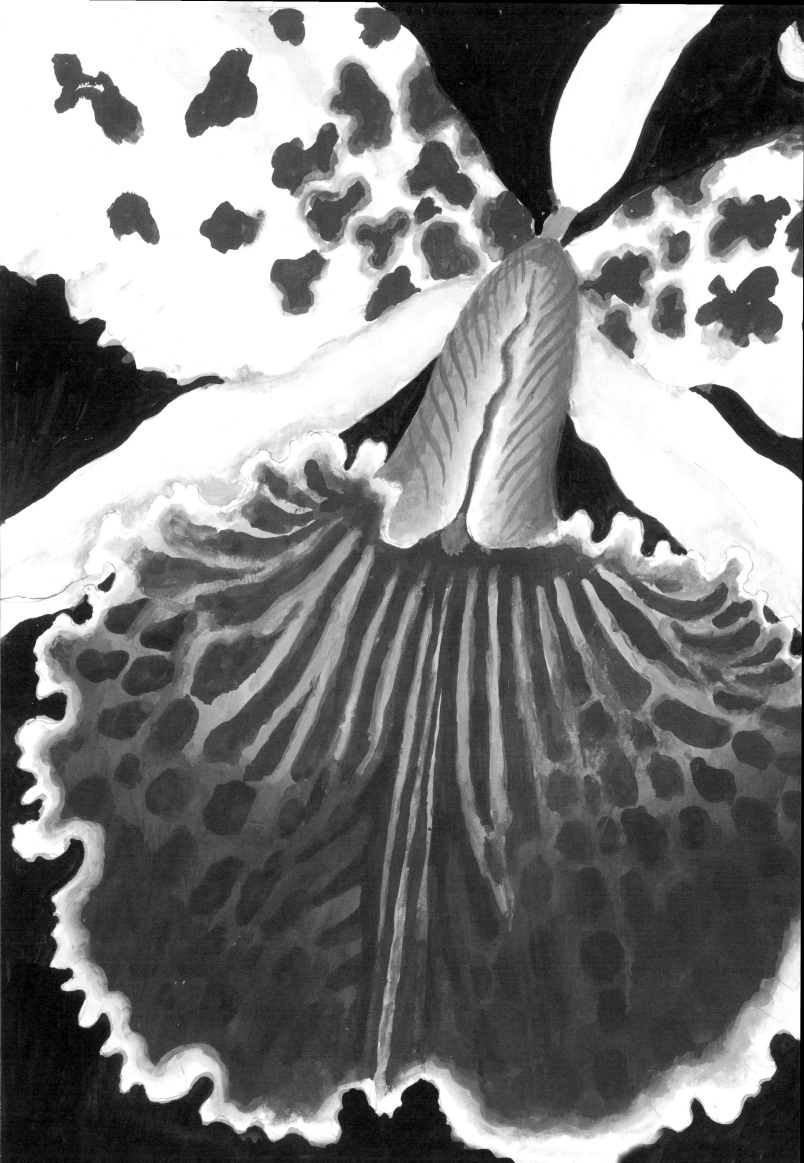

P

is FOR POPPY

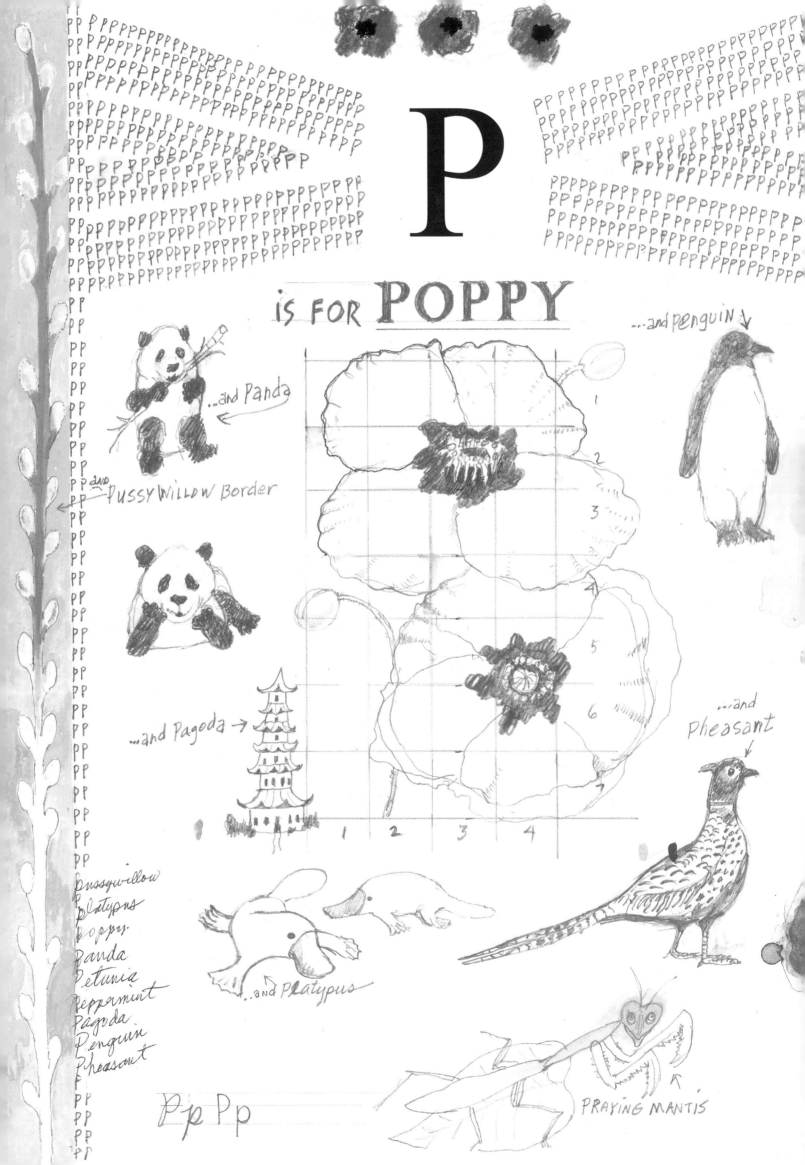

...and Panda

...and Penguin ↓

...and Pussy Willow Border

...and Pagoda →

...and Pheasant

...and Platypus

PRAYING MANTIS

Pussywillow
Platypus
Poppy
Panda
Petunia
Peppermint
Pagoda
Penguin
Pheasant

P p P p

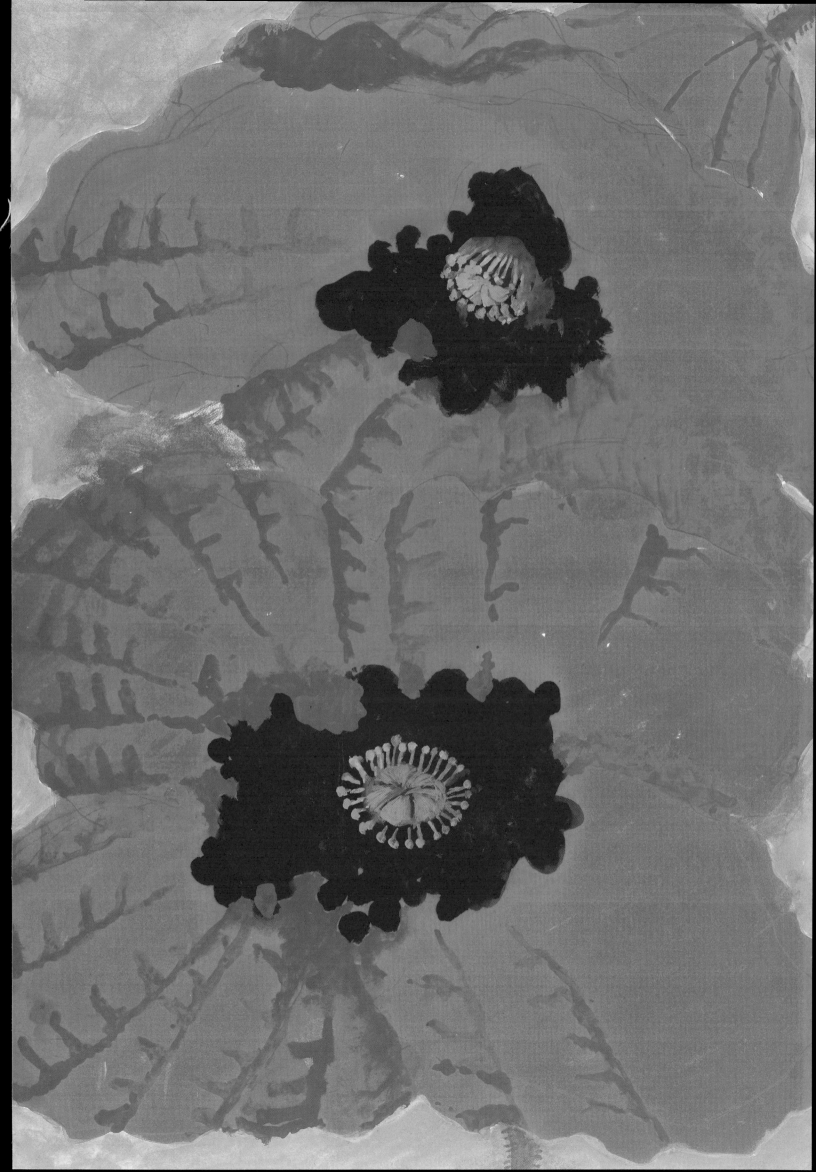

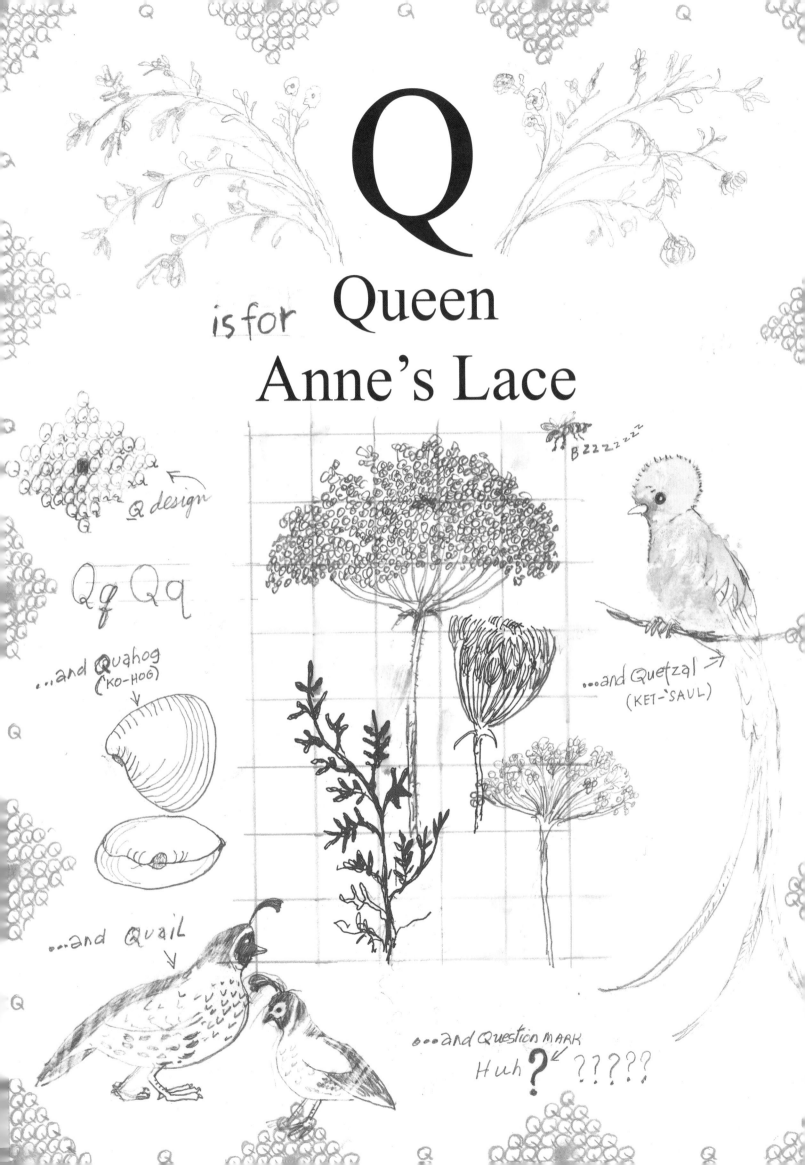

Q

is for Queen Anne's Lace

Q design

Qq *Qq*

...and Quahog
("KO-HOG")

...and Quail

Bzzzzzzz

...and Quetzal
(KET-'SAUL)

...and Question MARK
Huh? ??????

R

is for

Rose

...AND REINDEER

script Print

Rr Rr

rrrrrrr

...and Robins

...and Rhinoceros

and Rain

...and RING

...and Rabbit

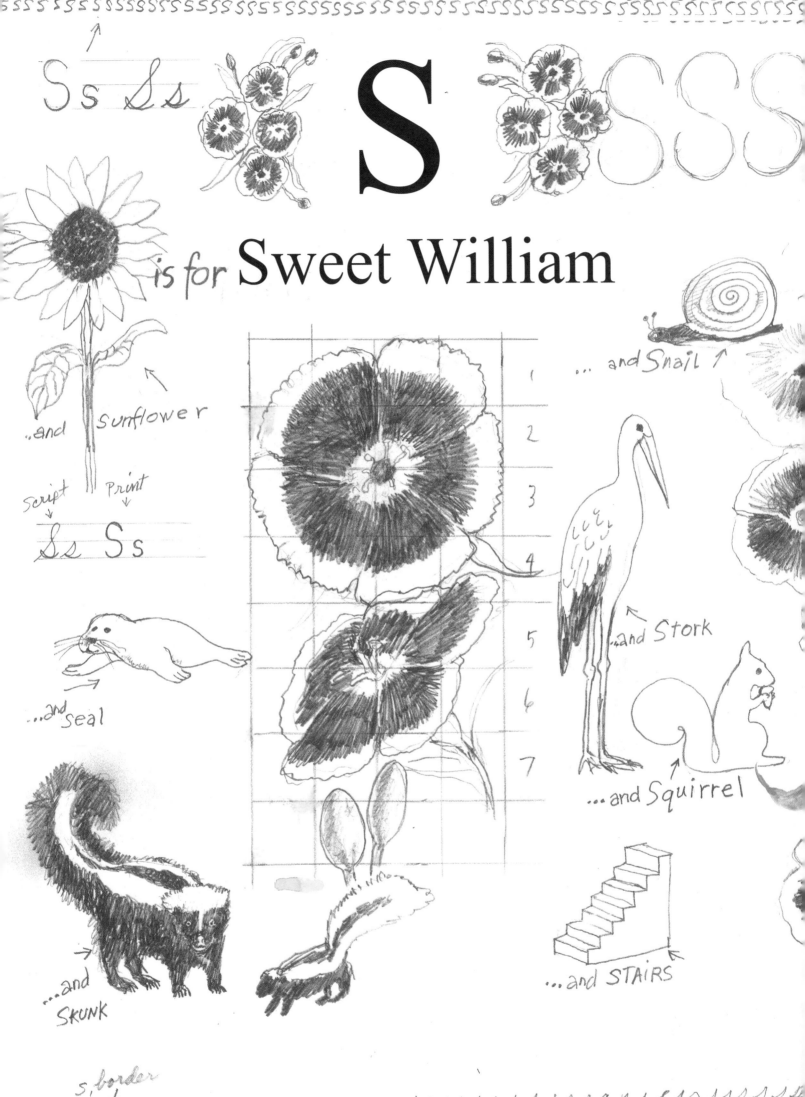

Ss Ss

S is for Sweet William

...and sunflower

script Print

Ss Ss

...and seal

...and SKUNK

1
2
3
4
5
6
7

... and Snail

...and Stork

...and Squirrel

...and STAIRS

s, border

T

is for TULIP

('TO-LIP)

this is a (Parrot) Tulip

...and Toucan
('TO-CAN)

"T" design

...and teeth

Tulip
Turtle

...and Tiger

...and → Turtle

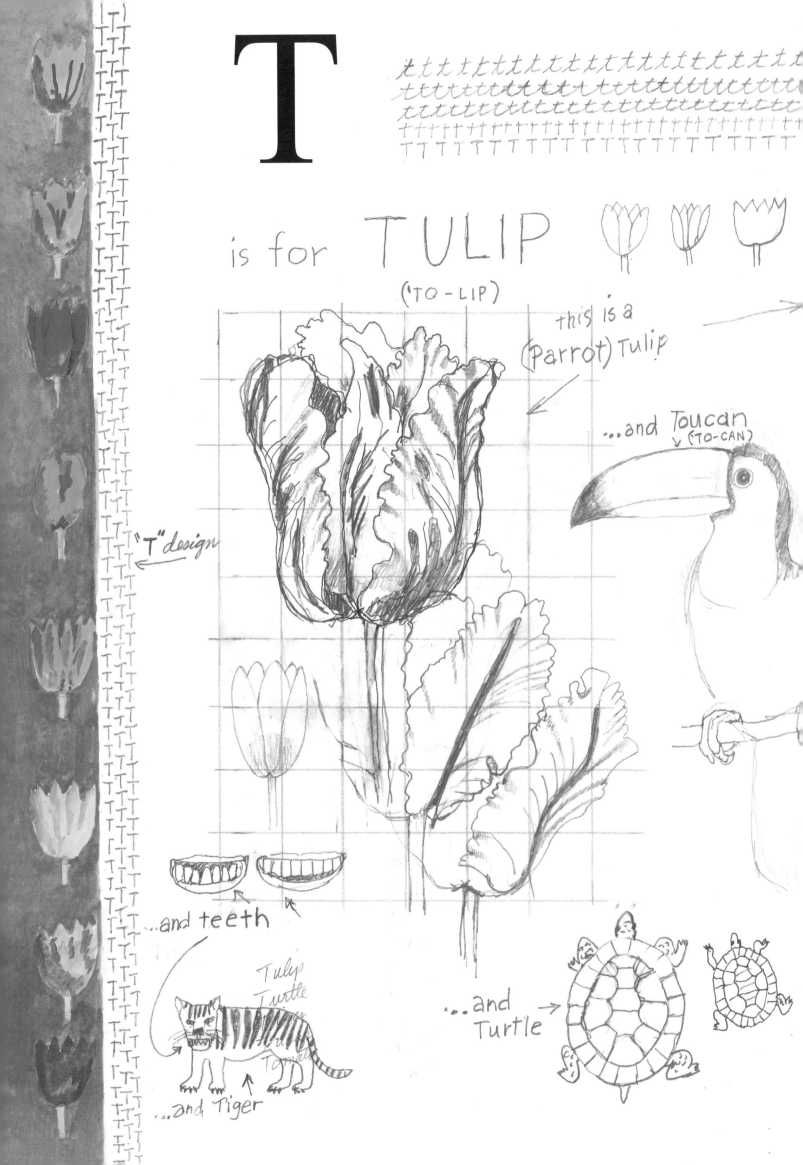

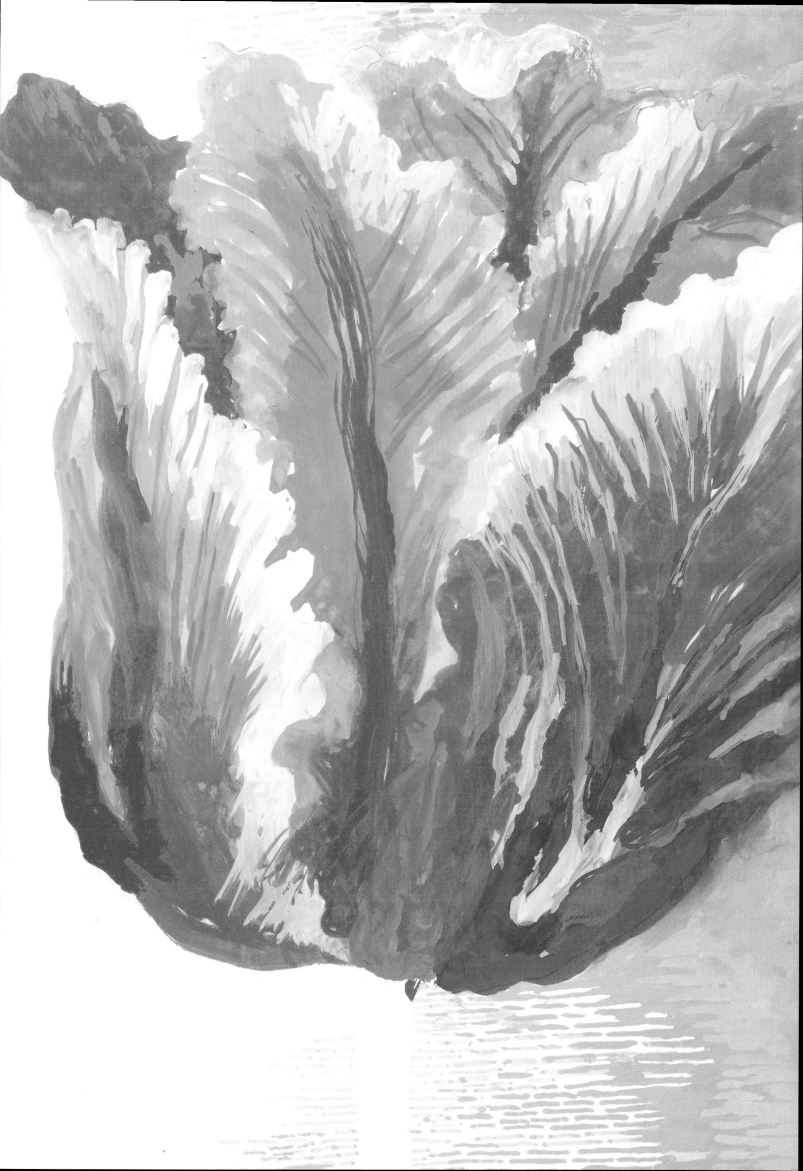

U is for Unknown

I couldn't think of a flower that started with U, so I made one up and named it _Umprella_.

all these flowers are made up. (unknown)

U design

unicorn

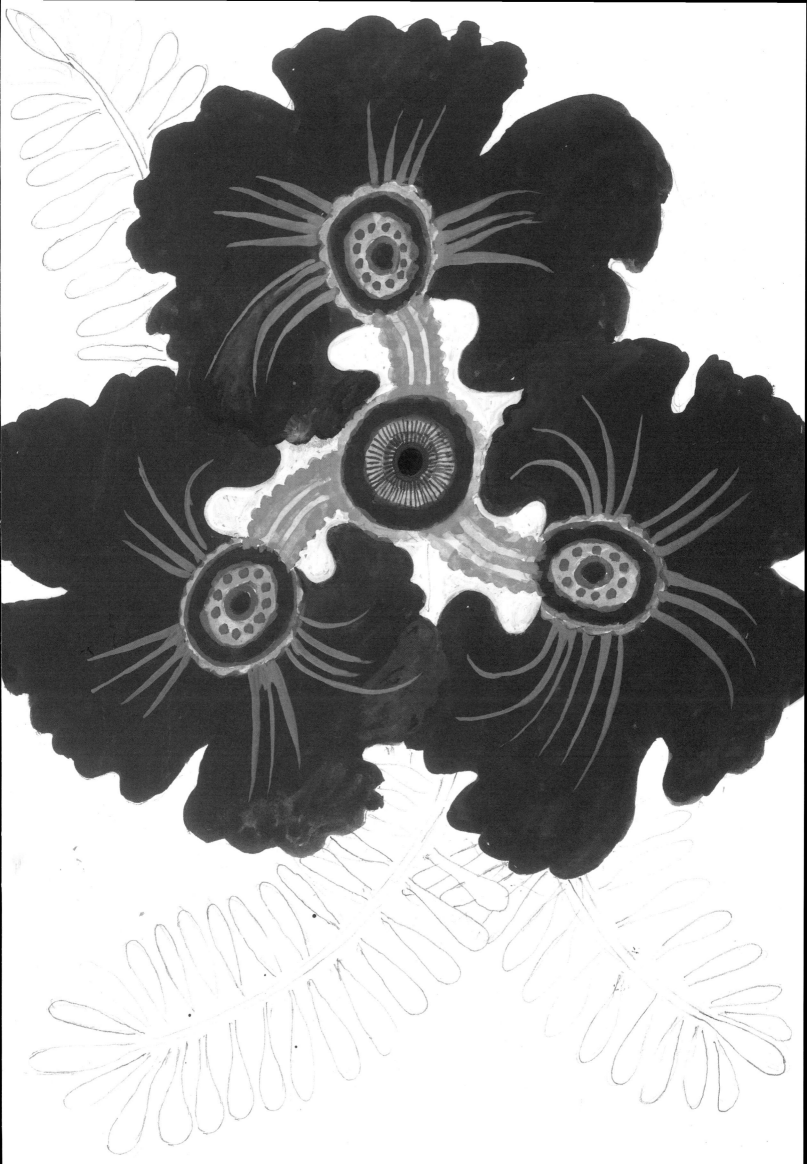

V

is for Vinca
(ˈVINK-AH)

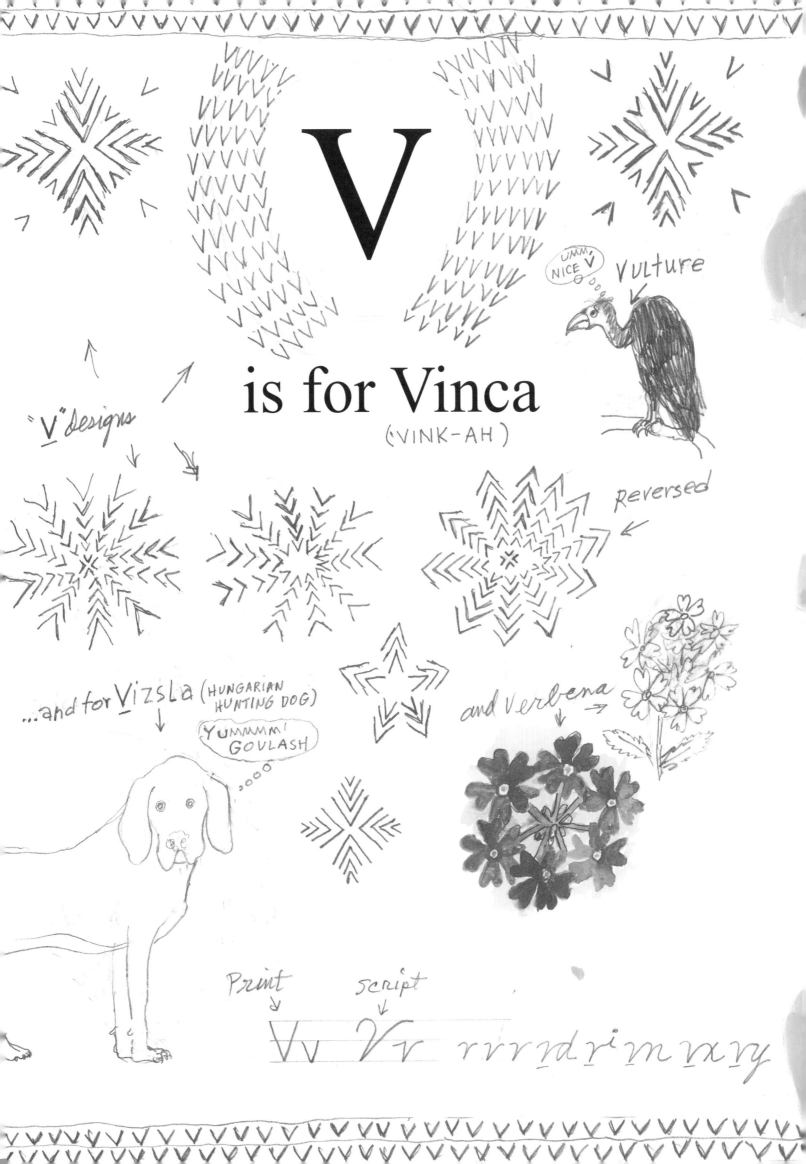

UMM, NICE V

Vulture

"V" designs

...and for Vizsla (HUNGARIAN HUNTING DOG)

YUMMMM! GOULASH

reversed

and Verbena

Print script

Vv Vv vvvvdrimvvy

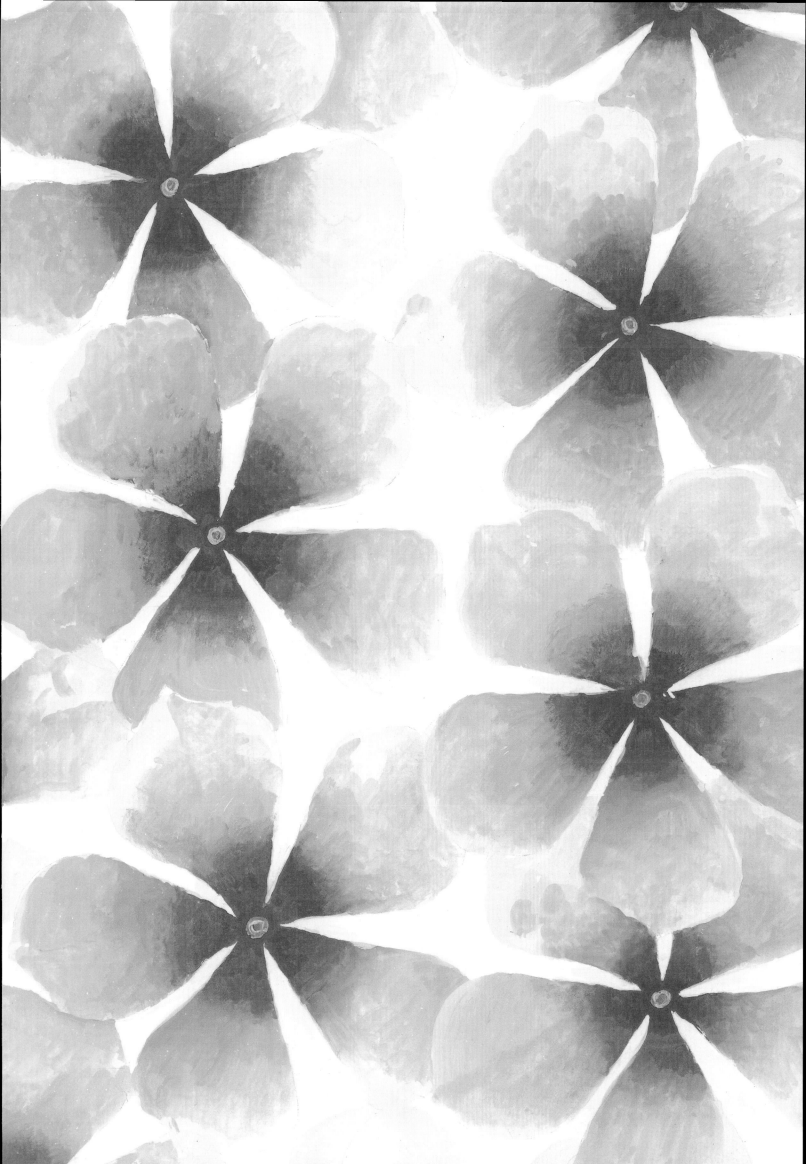

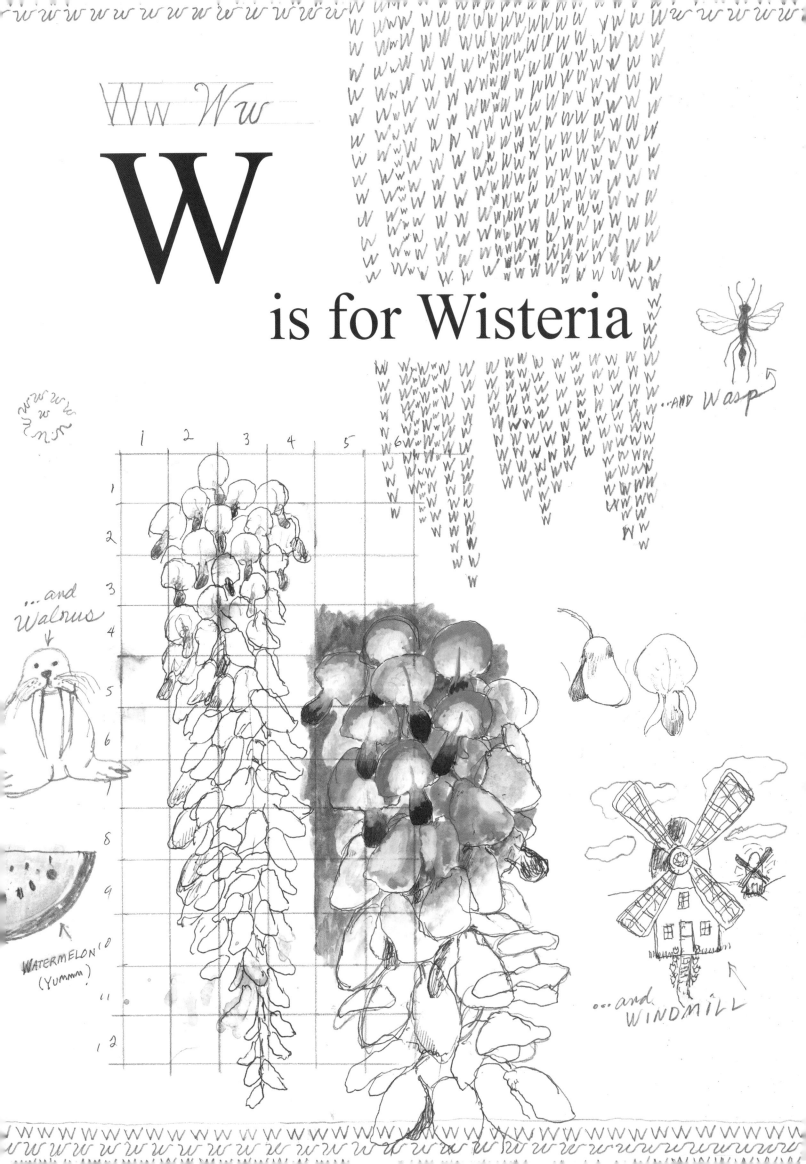

W w W w

W
is for Wisteria

...and Wasp

...and Walrus

WATERMELON
(Yummm!)

...and WINDMILL

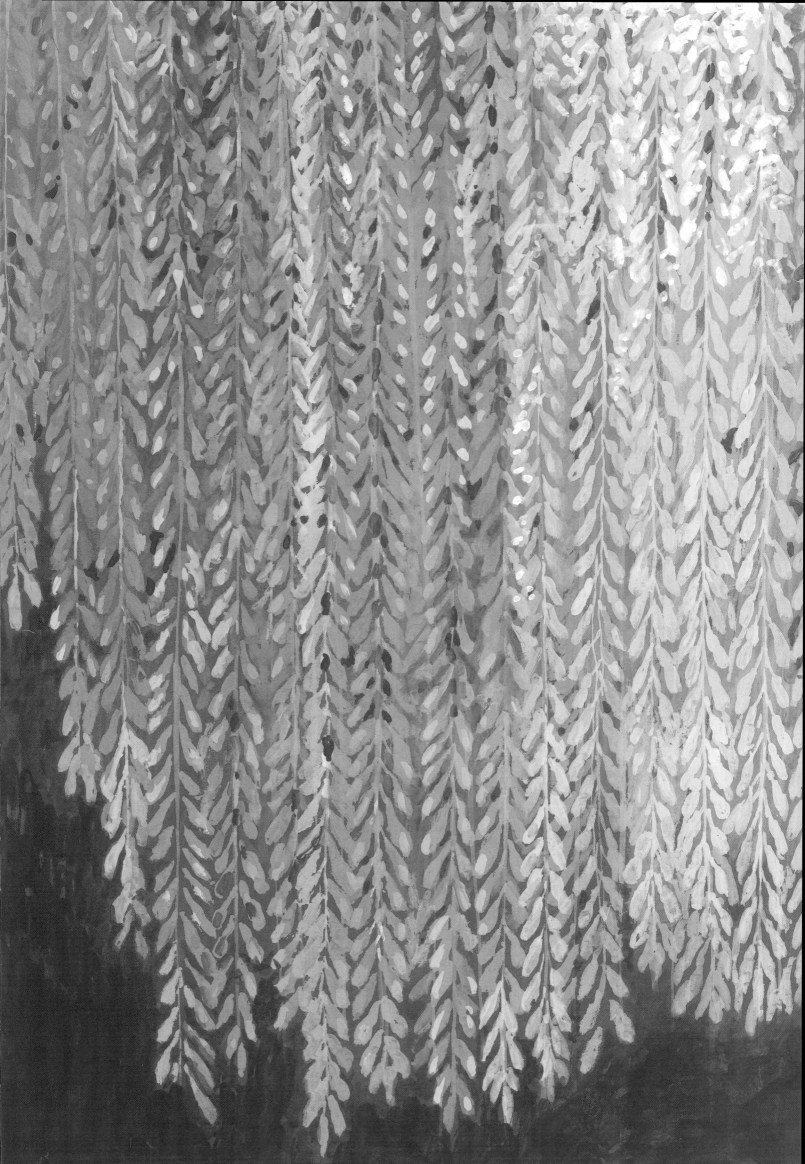

X
is for Xyris
(ZY-RĬS)

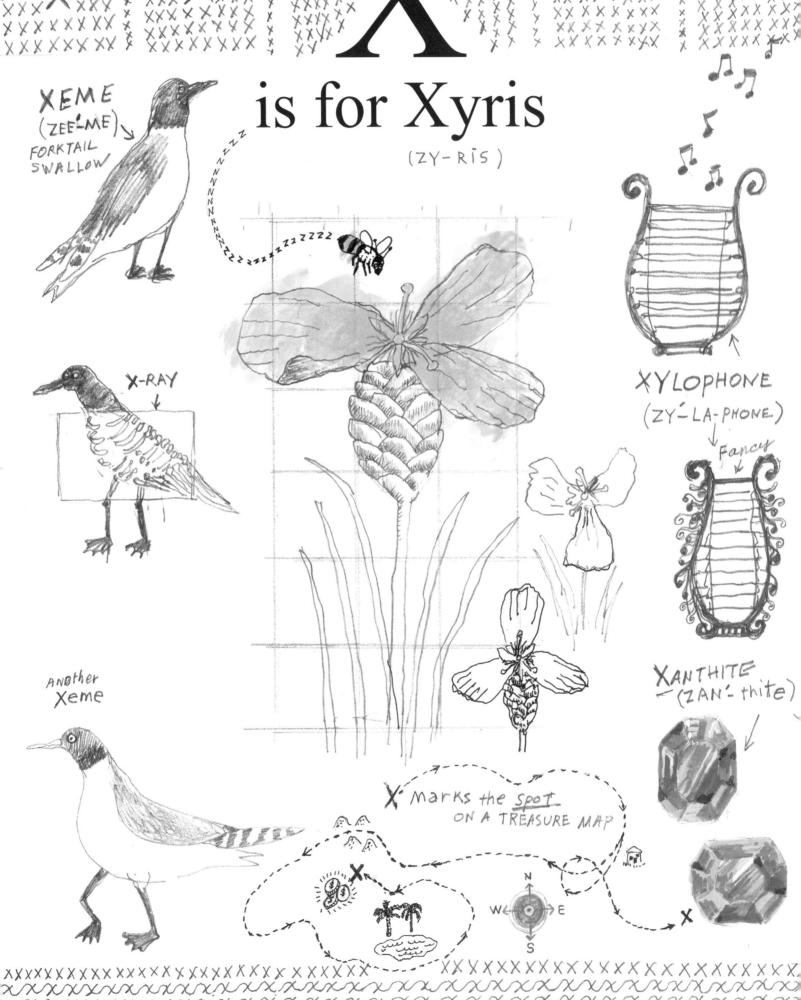

XEME
(ZEE-ME)
FORKTAIL
SWALLOW

X-RAY

Another
Xeme

XYLOPHONE
(ZY-LA-PHONE)

Fancy

XANTHITE
(ZAN-thite)

X Marks the Spot
ON A TREASURE MAP

N
W E
S

X design

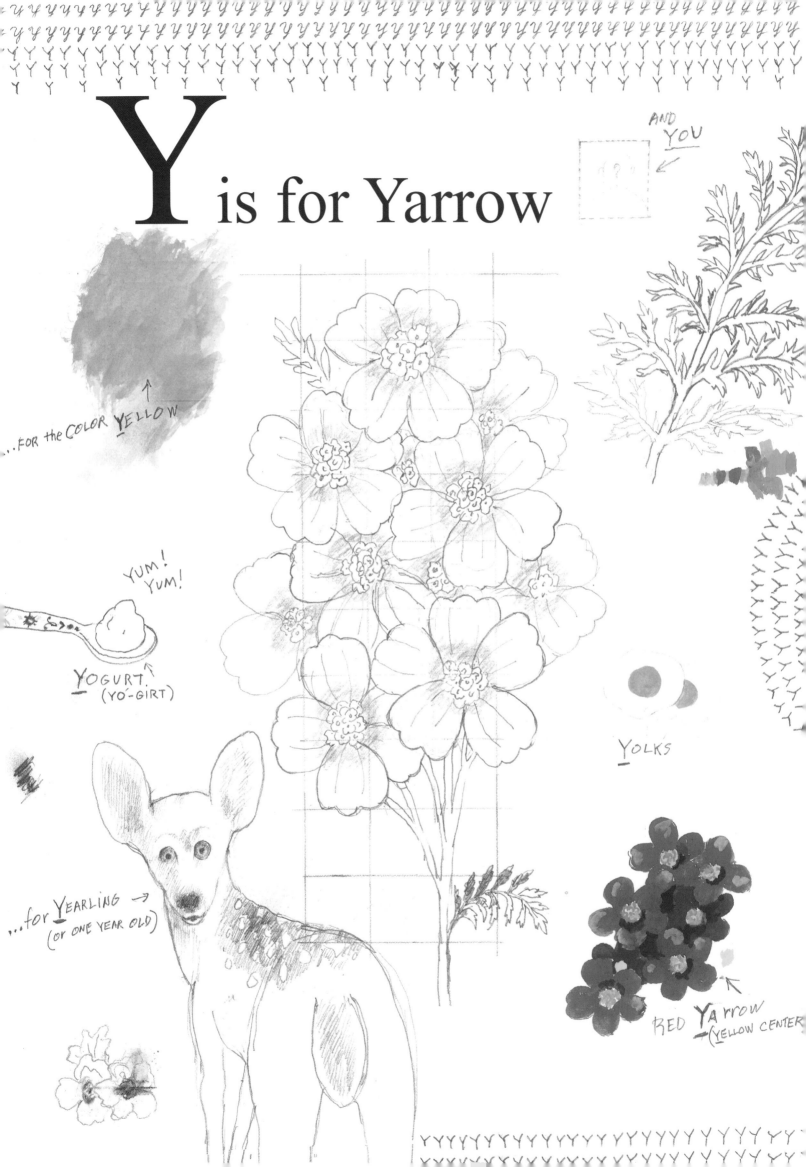

Y is for Yarrow

AND YOU

...FOR the COLOR YELLOW

YUM! YUM!

YOGURT. (YO-GIRT)

...for YEARLING → (or ONE YEAR OLD)

YOLKS

RED YArrow (YELLOW CENTER

THE LETTER Y

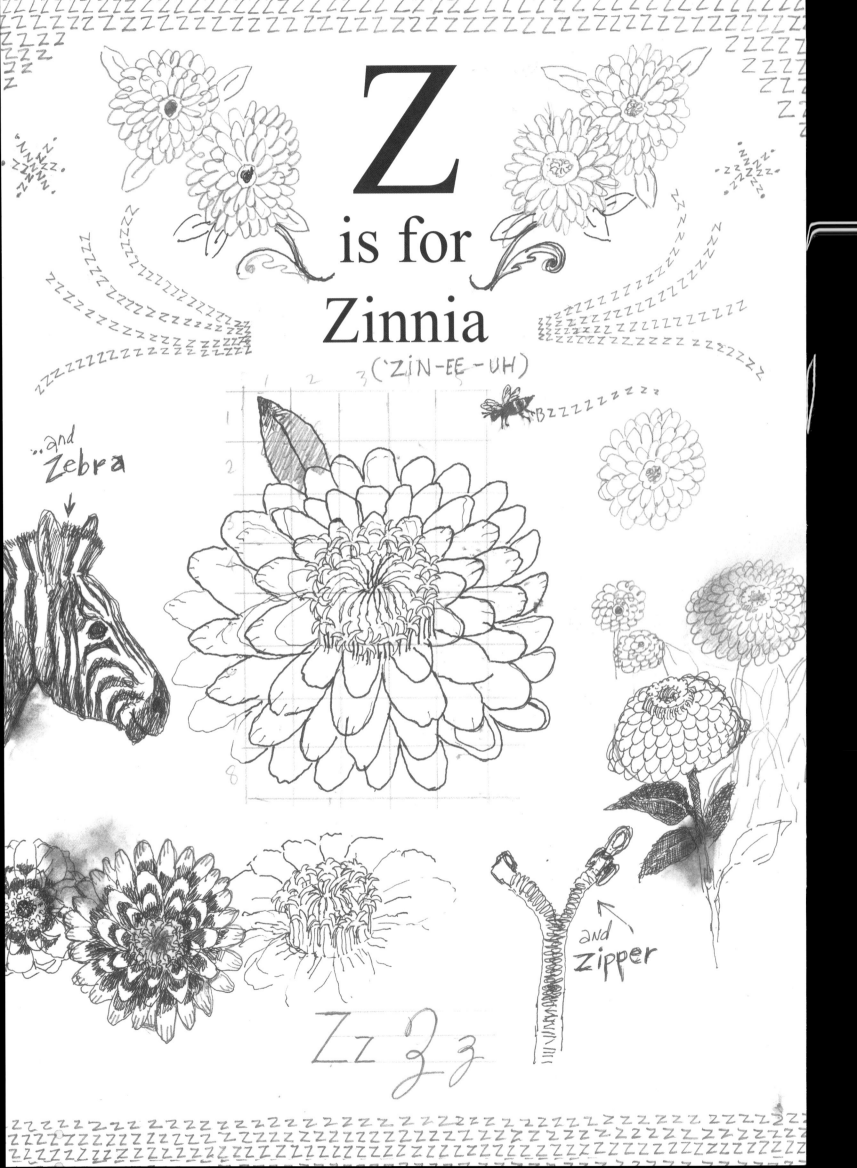

Z is for Zinnia

('ZIN-EE-UH)

...and **Zebra**

Bzzzzzzzz

and **Zipper**

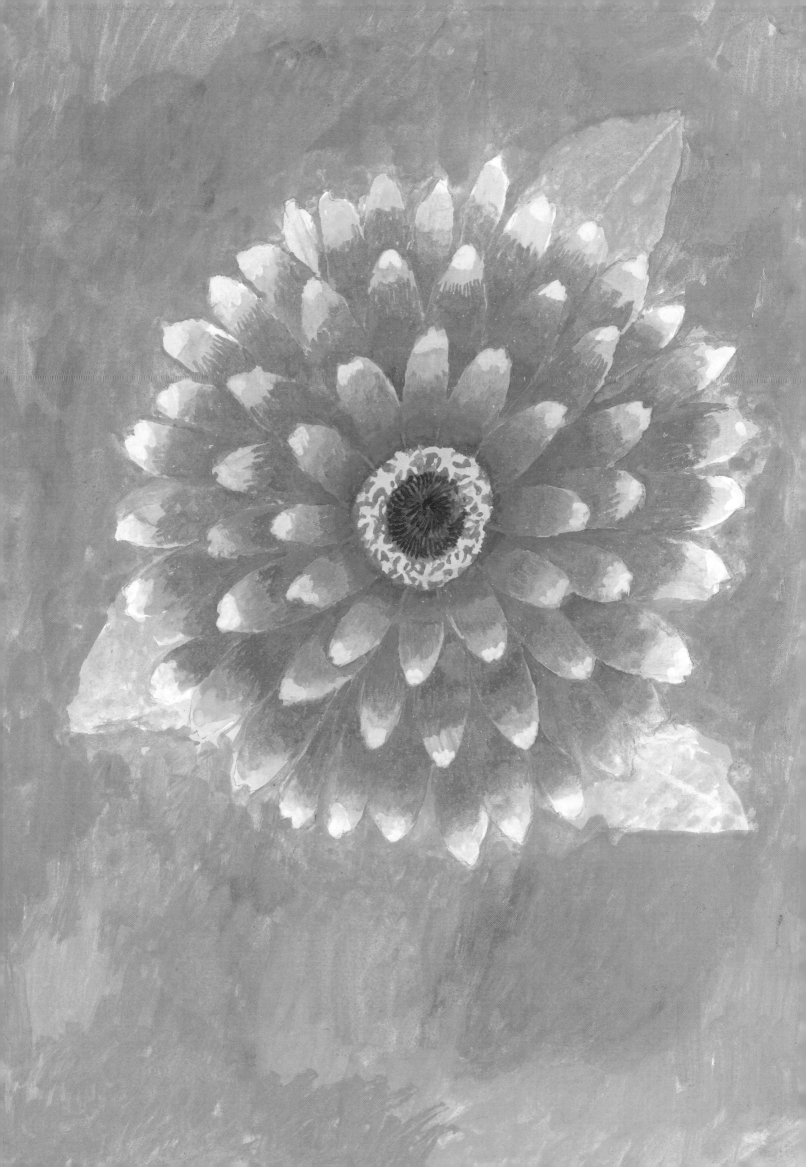

TO THE READER:

This book is a metaphor. I believe the universe is one magnificent and ever-changing garden. Interconnected to one another and to the farthest stars, we are an integral part of all that exists. This book is meant to remind us that we are all miracles growing and living in this glorious garden. We have the privilege and vital responsibility to tend it, and to tend it well.

TO THE CHILDREN:

You are at life's beginning, when everything is a wonder. You are at the very start of all possibilities of how to tend this garden. You are a miracle. This book is for you.

RRZ

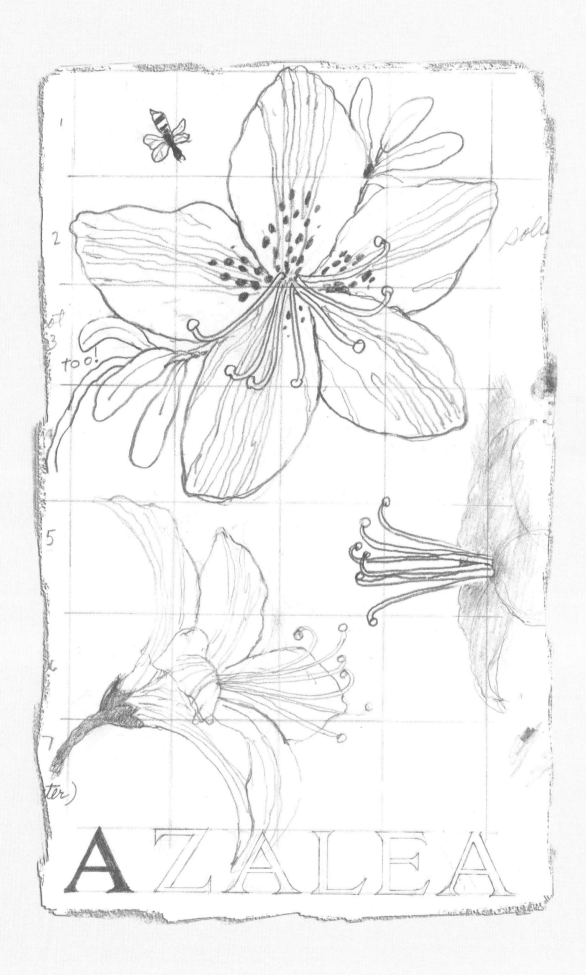

A B C D E F G H I J K L M N
O P Q R S T U V W X Y Z

a
Q
a b c d e f g h i j k l m n o p q r s t
u v w x y z

the letter u →

A A B C D E F G H I J K L M
M N O P Q R S T U V W
W
X Y Z 2
2

a b c d e f g h i j k l m n o p q r
mnop
abcdefghijk lmno mno nopqr
s t u v w x y z
abcdefghijklmnopqrstuvwxyz
abcdefghijklmnopqrstuvwxyz
abcdefghijklmnopqrstuvwxyz
aabcdefghijklmnopqrstuvwxyz aaaaabbbbbbccccccdda